NEW VANGUARD 249

RAILWAY GUNS OF WORLD WAR I

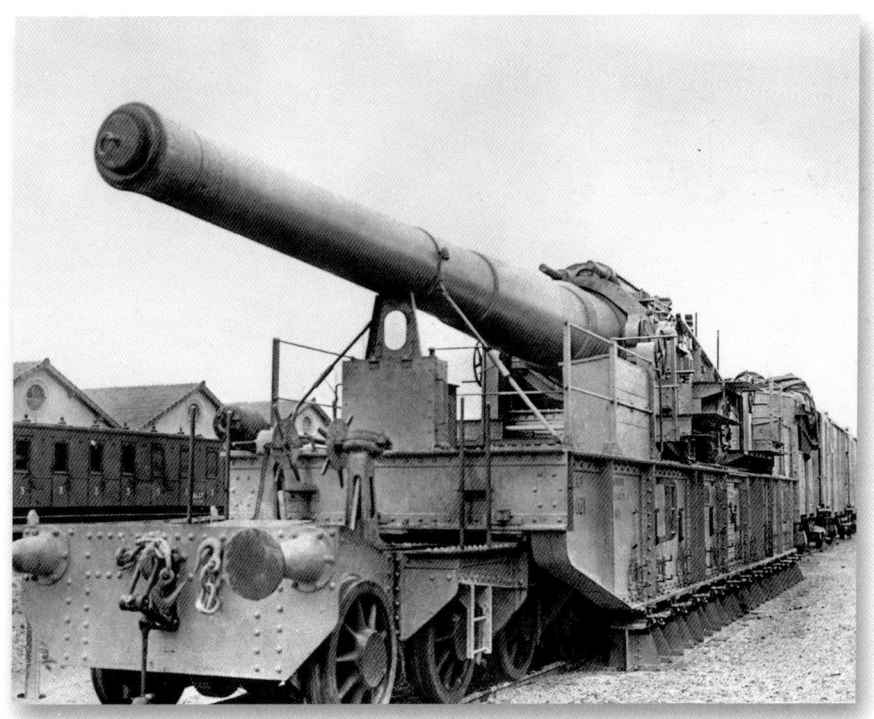

**MARC ROMANYCH
& GREG HEUER**

ILLUSTRATED BY STEVE NOON

Osprey Publishing
c/o Bloomsbury Publishing Plc
PO Box 883, Oxford, OX1 9PL, UK
Or
c/o Bloomsbury Publishing Inc.
1385 Broadway, 5th Floor, New York, NY 10018, USA
E-mail: info@ospreypublishing.com

www.ospreypublishing.com

OSPREY is a trademark of Osprey Publishing Ltd, a division of Bloomsbury Publishing Plc.

First published in Great Britain in 2017

© 2017 Osprey Publishing Ltd

All rights reserved. No part of this publication may be used or reproduced in any form without the prior written permission, except in the case of brief quotations embodied in critical articles or reviews. Enquiries should be addressed to the Publisher.

A CIP catalogue record for this book is available from the British Library.

ISBN: PB: 978 1 4728 1639 9
ePub: 978 1 4728 1641 2
ePDF: 978 1 4728 1640 5
XML: 978 1 4728 2715 9

17 18 19 20 21 10 9 8 7 6 5 4 3 2 1

Index by Fionbar Lyons
Typeset in Sabon and Myriad Pro
Page layouts by PDQ Digital Media Solutions, Bungay, UK
Printed in China through World Print Ltd.

ARTIST'S NOTE

Readers may care to note that the original paintings from which the colour plates in this book were prepared are available for private sale. All reproduction copyright whatsoever is retained by the Publishers. All enquiries should be addressed to: www.steve-noon.co.uk

The Publishers regret that they can enter into no correspondence upon this matter.

Imperial War Museums Collections

Many of the photos in this book come from the huge collections of IWM (Imperial War Museums) which cover all aspects of conflict involving Britain and the Commonwealth since the start of the twentieth century. These rich resources are available online to search, browse and buy at www.iwm.org.uk/collections. In addition to Collections Online, you can visit the Visitor Rooms where you can explore over 8 million photographs, thousands of hours of moving images, the largest sound archive of its kind in the world, thousands of diaries and letters written by people in wartime, and a huge reference library. To make an appointment, call (020) 7416 5320, or e-mail mail@iwm.org.uk

Imperial War Museums www.iwm.org.uk

Osprey Publishing supports the Woodland Trust, the UK's leading woodland conservation charity. Between 2014 and 2018 our donations are being spent on their Centenary Woods project in the UK.

To find out more about our authors and books visit **www.ospreypublishing.com**. Here you will find extracts, author interviews, details of forthcoming events and the option to sign up for our newsletter.

CONTENTS

INTRODUCTION 4

BEFORE THE WAR 4

DESIGN AND DEVELOPMENT 6
- Railway Gun Design
- Nomenclature
- 1914 and 1915: The First Railway Guns
- 1916: Greater Range and Firepower
- 1917: More Railway Guns
- 1918: Super-Heavy Railway Guns

OPERATIONAL HISTORY 33
- Organization
- Operation of the Railway Guns

EMPLOYMENT AND TACTICS 43

LEGACY OF THE RAILWAY GUNS 46

BIBLIOGRAPHY 47

INDEX 48

RAILWAY GUNS OF WORLD WAR I

INTRODUCTION

World War I was the Golden Age of railway artillery, with more types and numbers of these guns employed than in any other conflict. The impetus to build and field railway-mounted guns came from the stalemate of trench warfare. Built by the French Army in late 1914, the first railway guns were employed as heavy artillery support to frontline units. These guns were improvised designs made by mounting obsolete coastal defence guns and navy warship cannons onto existing commercial railway wagons. The British, German – and eventually the United States – armies followed suit and, by the last year of the war, railway guns were operating all along the Western Front. Railway artillery also operated on other fronts, with Italy and Russia building guns in 1917. As railway artillery proved its worth, the guns dramatically grew in sophistication, firepower and range. In contrast to the first railway guns, the later pieces were complete artillery systems with specialized rolling stock for ammunition, fire-control, personnel and technical stores. Accompanying the development of railway artillery guns were new indirect fire techniques for shelling targets up to 40km away. All told, more than 600 railway guns saw action during the war and, at the time of the armistice, several super-heavy pieces mounting barrels as large as 520mm were in development for fielding in 1919. After the war, the major armies kept railway guns in service, many of which were pressed back into action for World War II, although the number of railway guns employed from 1939 to 1945 nowhere approached the quantity fielded in World War I.

BEFORE THE WAR

Confederate forces fielded the first rail-mounted artillery piece in 1862 during the American Civil War. The gun was a 32-pounder naval rifle mounted on a flat railway wagon behind an armoured shield similar to that of an ironclad warship. Union forces then built two guns similar in design to the Confederate model. The next documented use of rail-mounted artillery was in 1882 during the Anglo-Egyptian War, when the British placed several naval guns on railway wagons to protect troop trains. This feat was repeated during the Second Boer War (1899–1902) by the Royal Navy, which rail-mounted naval and coastal defence guns for heavy artillery support to

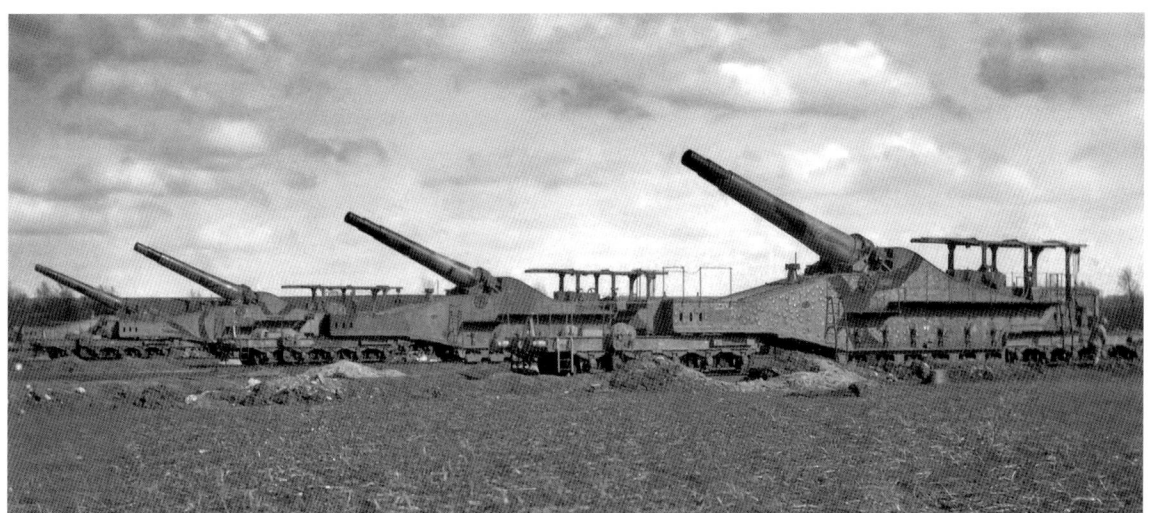

Four newly manufactured French 32cm Mle 1870/84 guns being readied for combat in March 1916. France built and employed more railway guns during World War I than all other nations combined. (G. Heuer)

the army. All of these artillery pieces were improvised field expedients constructed from available guns, rolling stock and materials. Their impact on combat operations was minimal.

In Europe, the idea of operating artillery on the railways began to emerge in the late 1880s. France, Britain, Germany, Austria-Hungary and Italy all experimented with rail-mounted guns, but only France followed through and, in 1888, became the first nation to purposely design and build a railway gun. By 1900 the French Army had 48 120mm and 155mm fortress cannons mounted on narrow-gauge wagons – called Piegne-Canet carriages – in service as fortress artillery at Verdun, Toul, Epinal and Belfort. But the army's interest ended there and it remained ambivalent about railway guns because heavy artillery, especially those on rails, did not fit with its offensive mindset. Meanwhile, as war approached, the firm of Schneider-Canet built and sold several types of guns mounted on standard-gauge railway wagons to other nations for use as mobile coastal defence or fortress guns – six 149mm howitzers for Denmark in 1894, six 152mm howitzers for Russia in 1910, two 200mm howitzers for Peru in 1910 and a 293mm mortar for Denmark in 1914 (although the guns for Peru and Denmark were never delivered). Likewise, the British Army, reflecting on its experiences in the Second Boer War, adopted a doctrine emphasizing mobile field artillery over heavy siege artillery. The army did experiment with mounting a 6in howitzer onto a narrow-gauge railway wagon, but the effort was short lived and railway guns, along with all heavy artillery, were dismissed as something more appropriate for its expeditionary forces.

The nations with the greatest appreciation for heavy artillery were Germany and Austria-Hungary. Faced with strong Belgian, French, Russian and Italian permanent fortifications along their borders, both nations actively developed and fielded mobile large-calibre siege guns. But neither nation's army considered having railway artillery, even though their armaments firms were experimenting with mounting field guns on railway wagons and the German firm of Rheinmetall had built a 12cm rail-mounted gun in 1908. Instead, the German and Austro-Hungarian armies viewed railways solely as a means of transport and not as firing platforms for the siege guns. Thus, in 1903, when the German Army wanted movable long-range artillery for

its fortress at Metz, it directed the firm of Krupp to build eight long-barrel 15cm cannons that mounted to fixed foundations, but moved to and from the emplacements by rail. At no time did the army consider permanently mounting the guns on railway wagons.

DESIGN AND DEVELOPMENT

Railway Gun Design

No pre-war initiatives predicted the technical innovation and variety of railway gun designs that appeared during the war. Railway artillery, as viewed by the armies of World War I, were artillery pieces, generally larger than 150mm (6in) calibre, mounted on, transported by and fired from railway carriages. In this sense, the German 42cm Gamma siege howitzer and the Paris Gun were not railway guns, but were foundation-mounted pieces transported by rail. Nor were the small-calibre guns that equipped armoured trains or rail-mounted anti-aircraft guns considered railway artillery. The first railway guns were simple, hastily built constructions meant to give mobility to heavy artillery, and each nation developed its own technical approach to construct the guns. French designers – the first to build a wartime railway gun – experimented with many different designs simultaneously, resulting in a diversity of railway gun configurations. The British Army developed railway artillery in a more measured manner, building a few basic types and calibres and then producing improved variants having different barrels, mounts and carriages. On the other side of the trenches, the German Army converted existing long-range cannons mounted on fixed-foundation emplacements into railway guns that could fire directly from the railway tracks but, for long-range fires, could still be mounted to ground platforms. Italy and Russia, which built only a few railway guns, generally followed the style of French designs. The United States, which was independently developing its own original railway gun designs for use as coastal artillery before entering the war, radically changed course upon declaration of war by buying and leasing technical material and guns from France. All told, some 40 different types of railway guns were fielded during the war.

The main components of a railway artillery piece were gun, gun mount and railway carriage. Of these three components, the type of gun (mortar, howitzer or gun, also called a cannon) and its characteristics (type, calibre, size and weight) governed the design of the mount and carriage. Most guns used for railway artillery were obsolete naval and coastal defence pieces. The challenge for the artillery manufacturers was to adapt the guns for use on rails and design elevation, traverse, recoil and anchorage systems that could absorb the recoil force of the gun. At first, most guns used to build railway artillery were relatively small-calibre pieces bolted onto a modified standard flat or depressed-centre railway wagon. Then, as longer and larger-calibre naval barrels came into use, railway carriage designs grew in size and complexity to accommodate increased weight and recoil of the bigger barrels.

Elevation mechanisms were a series of gears used to raise and lower the barrel for firing and loading. An elevation of 45 degrees or more was needed to achieve maximum range. While the mechanisms were fairly straightforward in terms of engineering, designing a mount and carriage that could accommodate the backward motion of the barrel when fired at

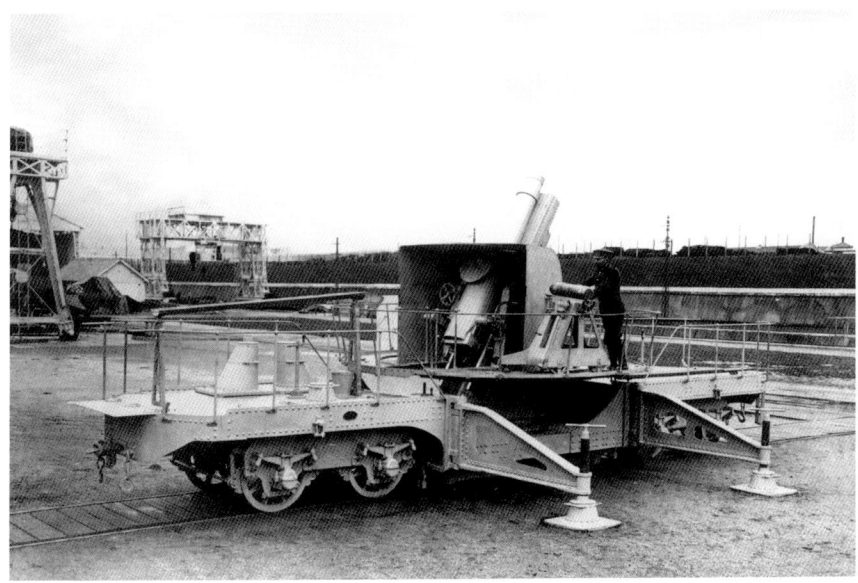

The first railway guns fielded in the war were two 200mm 'Pérou' howitzers built by the French firm of Schneider. Built before the war for use as mobile coastal artillery, the howitzers had all-around traverse, cradle recoil, a depressed-frame railway wagon and outriggers for anchorage. (G. Heuer)

high angle and meet the height, width and weight restrictions of European railways was problematic. Traversing mechanisms were more complicated and varied. Top-carriage traverse, often used early in the war, allowed gun and mount to rotate on the railway carriage from 10 degrees (limited traverse) to a full 360 degrees (all-around traverse) in azimuth. Outriggers were sometimes added to stabilize the carriage. Top-carriage traverse was used with small-calibre and short-barrel weapons, and was greatly favoured by the British Army. At the opposite end of the design spectrum were non-traversing guns with no internal mechanism to adjust the azimuth of the barrel. These guns were aimed by moving the entire weapon along a curved segment of rail called a firing track until the barrel pointed in the direction of the target. Many large, heavy railway guns, particularly French sliding-mount railway guns built by Schneider, were non-traversing designs. A third system, carriage-traversing, was also used with large-calibre guns, typically in combination with a curved firing track. For minor changes in azimuth, the carriage itself was adjusted left or right on its bogies, giving the gun and mount a few degrees' movement to either side, while a curved firing track was still used to obtain major azimuth changes.

Recoil systems absorbed the force produced by firing the gun. The most sophisticated system, cradle recoil, used springs or recuperators to retard the rearward motion of the gun barrel and return it to firing position while the mount and carriage remained stationary. A simpler design was top-carriage recoil, an improvisation used by the French to mount old coastal defence guns and mounts directly onto flat railway wagons. When fired, the barrel and carriage recoiled together by moving up an inclined slide. Another design, sliding recoil, was common to many French Schneider-built heavy railway guns. A series of jacks and wood sleepers on the bottom of the carriage were used to distribute weight and absorb the gun's recoil. The wood sleepers themselves rested on a series of steel beams that reinforced the railway tracks and formed a platform upon which the entire weapon slid backwards when fired. Recoil was absorbed by friction, as the entire railway gun slid a metre or more along the beams. To return the gun to firing

position, the carriage was jacked up onto its bogies and moved forward by gears powered by hand wheels or electric- or petrol-driven motors. Rolling recoil was used by railway guns that could fire from a standard railway track with all weight on the bogies. When fired, the entire railway piece rolled backwards as much as 15 metres, using only its brakes to absorb the recoil and stop the gun. A winch was used to return the mount to its firing position. To prevent damage to carriage and rails, the heaviest guns used cradle recoil systems and longer bogies with 12 or more axles to distribute and reduce downward pressures on the rails.

Anchorage systems were used to stabilize railway guns during firing operations. Guns without anchorage relied on weight to keep the carriage and bogies on the firing track. Sliding mount guns were anchored to track platforms with hook-like metal grips called rail clamps that held the carriage to the platform and prevented the recoil from lifting the railway gun off the tracks. Smaller-calibre guns, especially those with 360-degree traverse, used outriggers, braces or steel cables with ground anchors to prevent the artillery piece from toppling over when firing perpendicular to the railway track. High-powered railway guns often used ground platforms for long-range fire. The ground platforms were constructed of wood timbers, concrete or steel beams built into or under the firing track and included an excavated pit to accommodate the barrel's recoil. The French and American armies used this type of foundation. German railway guns operated from sunken concrete or steel foundations with a turntable for all-around traverse.

Nomenclature

Each army had its own nomenclature system for railway artillery. French nomenclature included the type of gun, barrel size, model year of the barrel, type of mount and manufacturer. Gun types were *mortier* (mortar), *obusier* (howitzer) and *canon* (cannon). Barrel sizes were expressed in millimetres or centimetres. Older cast-iron barrels were denominated in centimetres, such as the 32cm modèle 1870/84; while newer steel barrels were denominated in millimetres, such as the 305mm modèle 1893/96. *Modèle* (model) was often abbreviated as 'Mle'. The mount types were *tous azimuts* or TAZ (all-azimuth), *glissement* (sliding), *berceau* (cradle mount with the recoil mechanism), as well as *circonstance* and *fortune* (translated as 'emergency' and 'fortune'), which were mass-produced mounts hastily built to get old coastal artillery pieces onto the railways. An example French designation was 'Canon de 32cm modèle 1870/74 sur affût à glissement Schneider' or simply the '32cm Mle 1870/74'.

British railway guns were breech-loading (BL) artillery pieces designated as either a gun or howitzer. Barrel size was measured in inches and a Roman numeral 'mark' number (abbreviated as Mk) used to identify the model of barrel; for example, a '9.2in Gun Mk III'. Carriage and railway wagon variants were also identified by 'mark' numbers. Thus, an example nomenclature for a British railway gun was 'Ordnance BL 9.2in Gun Mk III on Mounting, Truck Railway Mk I' or, in summary fashion, '9.2in Gun Mk III'.

German nomenclature included barrel size, type and length, and in some cases a codename. Barrels were measured in centimetres and identified as either a *Kanone* (cannon) or *Schnelladekanone* (fast-loading cannon); abbreviated as 'K.' and 'S.K.', respectively. Barrel length was expressed in calibres and indicated by using the prefix 'L/' for *Lange* (long). Codenames were often,

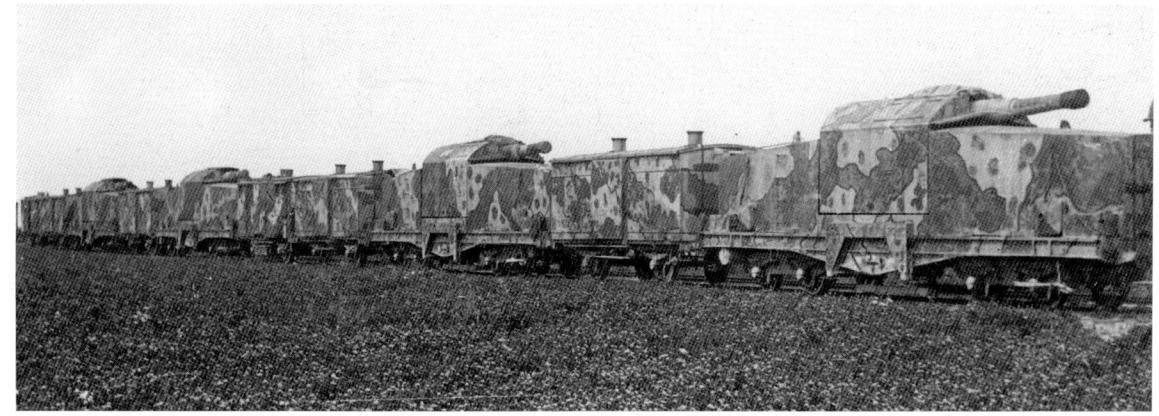

The armoured French 19cm Mle 1870/93 was the first railway gun manufactured in significant numbers during the war. These four guns, photographed in 1916 or later, are assembled in a rear-area cantonment while awaiting action at the front. (G. Heuer)

but not always, proper names that shared the first letter of the name of the ship from which the guns came; e.g. 'Bruno' was derived from the SMS *Braunschweig*. Because guns were used in different configurations, the type of mount – *Bettungsgerüst* or 'B.' (fixed platform), *Eisenbahn* or 'E.' (railway) or *Eisenbahn und Bettungsschiessgerüst* or 'E.u.B.' (railway and firing platform) – was sometimes added to a gun's designation. An example of German nomenclature was '24cm Kanone L/30 Theodor Otto E.u.B.', shortened to either '24cm K. L/30' or just 'Theodor Otto'.

American railway gun nomenclature varied, but generally included the barrel size in inches along with the gun type (i.e. gun, naval gun or howitzer) and model number of the railway carriage expressed as either the year of design (e.g. M1918) or a mark number. For example, '16-inch Howitzer on Railway Mount, Model 1918' is abbreviated as '16in M1918 Howitzer'.

1914 and 1915: The First Railway Guns

Once the Western Front had stabilized in the autumn of 1914, the opposing armies realized the value of long-range, heavy artillery for shelling targets behind enemy lines. The French Army, critically short of heavy artillery, rapidly fielded several rail-mounted guns in an effort to increase artillery firepower at the front. In early October, the army requisitioned the two rail-mounted 200mm howitzers Schneider had built for Peru in 1910 as coastal defence weapons. Designated the 200mm Obusier 'Pérou' (Peru), both howitzers were rushed to action in Belgium to help stem the German offensive against the Channel ports and remained in service for the duration of the war. An oddity of the howitzers was their 200mm calibre which was used by the army and required specially manufactured rounds. The army also directed Schneider to mount six long-barrelled 155L 'Transvaal' cannons on flat railway wagons for counter-battery missions at Verdun. The cannons – so named because they were made for the South African Republic (Transvaal Republic) during the Second Boer War – had a range of 12,700m, which was longer than most German artillery of the time. Fielded in the first half of 1915, the guns performed well during artillery duels at Verdun. The army also removed artillery from seacoast fortifications and directed the Société des Batignolles to mount 16 95mm cannons on lightly armoured railway wagons to use with armoured trains; however, their utility was short-lived, as the trains, and cannons, were removed from service in 1916. Of these first rail-mounted guns, only the 200mm Pérou pieces were assigned to the

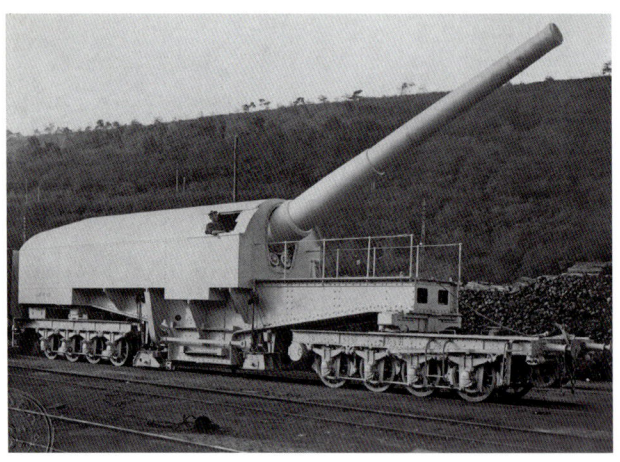

Even though the steel-plate armoured housing of the 274mm Mle 1893/96 limited its barrel elevation to 25 degrees, the gun still had a very good maximum range of 22,200m when it was fielded in the summer of 1915. (G. Heuer)

railway artillery. The smaller-calibre 95mm Mle 1888 and 155L Transvaal cannons were used by the regular heavy artillery.

In October, the French High Command (Grand Quartier Général, or GQG) instituted a programme for the construction of *artillerie lourde à grande puissance* or ALGP (high-powered or long-range artillery larger than 155mm). The programme directed the manufacture of 39 high-powered pieces using a variety of guns taken from coastal fortifications and naval reserve stocks, of which about half were built as railway artillery. Although these rail-mounted guns were deliberately engineered pieces, they were still improvised to accommodate the peculiarities of the coastal defence and naval gun mounts. Nevertheless, the guns represented a significant leap forward in range and firepower.

The first of these railway guns to enter service was the 19cm Canon Mle 1870/93 built by Schneider. The entire carriage was armoured with steel plate and the cannon was turret-mounted for all-around fire. The recoil and anchorage systems were a makeshift combination of top-carriage recoil, foot plates on screw jacks, and rail clamps for stabilization. With a range of 18,300m, the gun could easily shell targets deep behind German front lines. A total of 26 pieces were built, with the first guns fielded in April 1915. Schneider, using long-barrelled naval cannons, also made an artillery piece with even greater range, the 274mm Canon Mle 1893/96 (berceau). To accommodate the barrel's weight and length, the mount and railway wagon were constructed as a single unit. The gun had a sophisticated wagon-traverse mechanism, but still needed a curved firing track for pointing the barrel at

THE FIRST RAILWAY GUNS
1. French 200mm Obusier 'Pérou'

Soon after the war began, the French Army requisitioned two pre-war built 200mm 'Pérou' howitzers from Schneider's manufacturing facility in Le Havre. The howitzers were part of a complete rail-mounted weapon system that included an ammunition wagon and observation wagon equipped with a telescoping periscope. The French Army organized the howitzers into an artillery battery – the 51e batterie du 1er Régiment d'Artillerie à Pied – and sent them into action in October 1914. Early-war French railway guns and ammunition wagons were painted light artillery blue until replaced by solid green or pattern-painted camouflage in late 1915.

2. French 19cm Canon Mle 1870/93

The 19cm Canon Mle 1870/93 was the first railway gun completely designed, built and fielded during the war. The gun and its ammunition wagon were armoured with steel plate to protect the crew when operating near the front line. The first guns entered service in April 1915 and served throughout the war.

3. British 9.2in Guns Mk I and Mk III

The first British railway gun was an ad hoc 9.2in piece built by the Elswick Ordnance Company in September 1914. Although the gun did not see action, it served as the basis for a series of rail-mounted guns that were fielded beginning in late 1915. Shown here are two versions of 9.2in guns that did see combat: the 9.2in Gun Mk I (left) and the 9.2in Gun Mk III (right). For stability, the railway wagons were lowered onto the railroad ties before firing. Later models had outriggers for increased stability. These railway guns were painted a mid-green colour with differences in tone due to production variations. Camouflage patterns were often applied in the field.

1

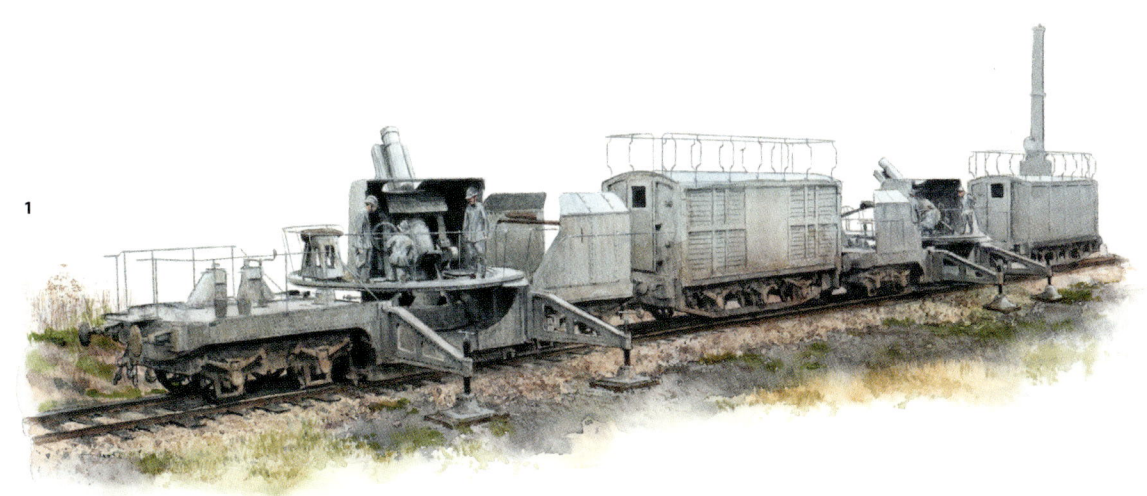

2

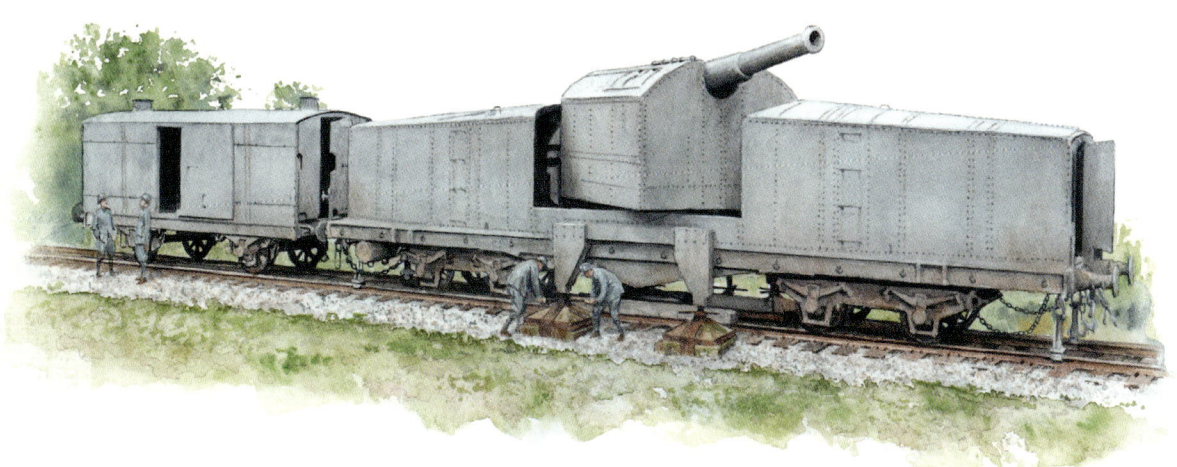

3

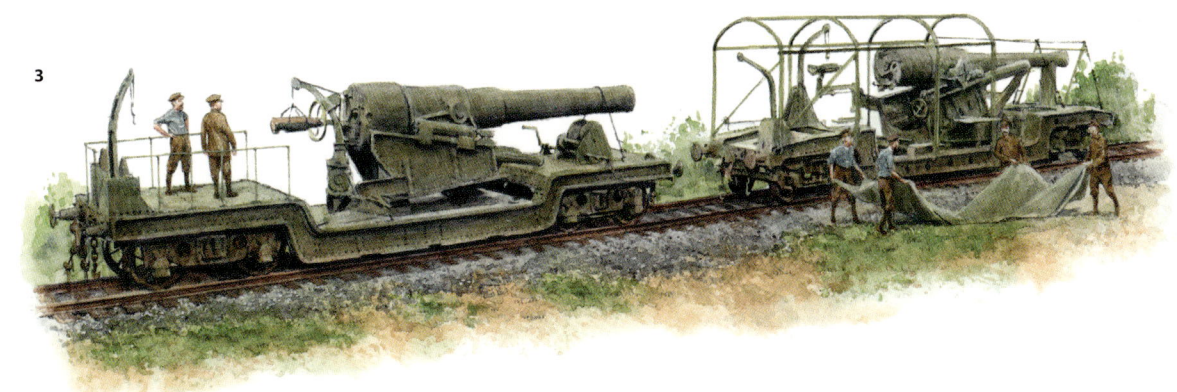

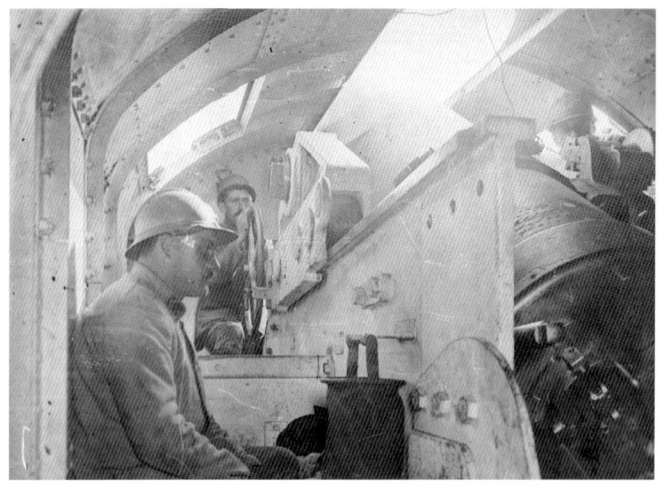

French gunners inside the armoured housing of a 274mm Mle 1893/96 at Villers-Daucourt in the Argonne region on 1 June 1916. Designed to protect the crew and gun from shelling by German counter-battery fire, the armour actually hampered operation of the gun. (IWM Q 108336)

its target. The army saw little value in the complexities of wagon-traverse, and no other guns were designed with that feature. Like the 19cm Mle 1870/93 gun, the 274mm Mle 1893/96 was also armoured for crew protection, but the steel plate housing limited operation of the weapon. Only four of the guns were built, but because of their long range – 22,200m – they saw frequent use, and when the 19cm barrels wore out, they were replaced with larger-calibre 285mm and 288mm tubes. The success of Schneider's 274mm railway gun led to the construction of artillery carrying larger and longer naval cannons.

Two other French firms – Saint-Chamond and Society Batignolles – also manufactured railway guns, but their first designs, which used long-barrel cannons, had technical difficulties. Saint-Chamond constructed eight 305mm Canon Mle 1893/96 (châssis) by placing old coastal defence cannons with rotating mounts onto railway wagons. The first gun was delivered in early 1915, with eight built by the end of the year. However, once in action, the 305mm cannon proved too powerful for its mount so, in 1917, the cannons were replaced with smaller 240mm calibre cannons. Meanwhile, Society Batignolles built eight 24cm Canon Mle 1870/87 and 1870/93 using old 24cm naval cannons and turntable mounts (the two model numbers designate the different barrels used). The guns were fielded by the end of 1915 but experienced problems because the barrels were fragile. After about a year of service, the guns received new barrels and were re-designated the 240mm Mle 1884 and 1917. Even though the Saint-Chamond and Batignolles guns remained in service to the end of the war, the use of rotating or turntable mounts for large-calibre railway guns did not catch on with French artillery designers.

In March 1915, GQG initiated a second ALGP construction programme that greatly increased the number of railway guns in service and ultimately gave the French Army more railway guns than all other armies combined.

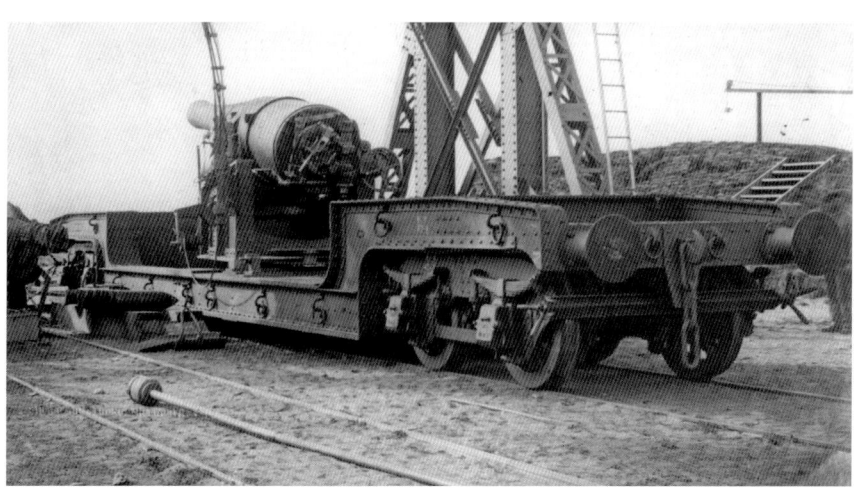

Britain was the second nation to employ railway artillery during the war. One of its first railway guns was the 9.2in Gun Mark III made from surplus coastal defence guns mounted to commercial railway wagons by Armstrong, Whitworth & Company at its Elswick works in Newcastle. (G. Heuer)

12

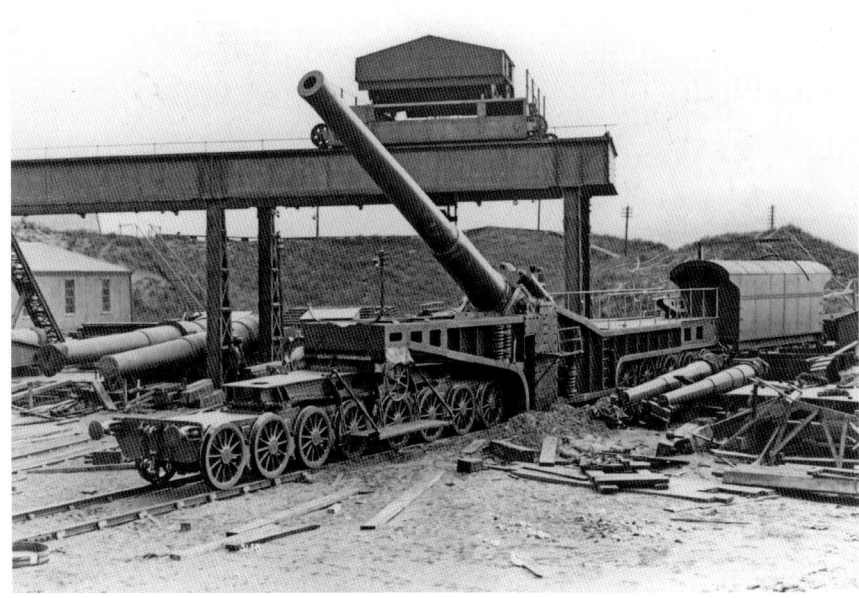

Built in 1915, Vickers' two rail-mounted 12in Mark IX guns were the British Army's first large-calibre railway artillery pieces. Innovative in design, the guns had a distinctive open box-girder frame and exceptionally large multi-wheeled bogies. (G. Heuer)

The programme directed construction of 344 artillery pieces, including 143 railway guns, with the firepower to destroy deeply buried concrete fortifications and range for engaging German long-range artillery operating from fixed foundations opposite Dunkirk, Verdun and Compiègne. The first of these guns were delivered in early 1916.

The British Army, also realizing it needed more heavy artillery, built its first railway gun soon after war commenced. The gun, built by Armstrong, Whitworth & Company at its Elswick Ordnance Company Works, was an improvised design that mounted a 9.2in coastal defence gun onto a commercially available railway wagon. Completed in September 1914, the gun was shipped to France in October, but French authorities refused to let it onto the rail lines so it was sent back to Britain. Nothing more transpired with the gun until a year later, when the army directed Elswick to build more of the guns for heavy artillery support to the frontline. Designated the 9.2in Gun Mark I on railway mounting, the artillery pieces were manufactured using a variety of surplus 9.2in coastal defence guns on old-style mounts. The first 9.2in railway guns were sent to France in late 1915 where they performed satisfactorily, although several shortcomings were noted, particularly its traverse, which was limited to 10 degrees left and right, and the mount's lack of elevation, which limited its range to 11,800m. To improve performance, Elswick fabricated a field modification kit that provided greater elevation to the barrel. Beginning in March 1916, the kits were retrofitted to those railway guns already in France, while guns in production were redesigned to improve operation and performance. These later versions of the 9.2in railway gun were built using a variety of coastal defence barrels (Marks III, IV, IVa, VI, VIa, VIb and VIc) mounted to several types of railway wagons (the basic Mark I wagon, or a lengthened Mark Ia or Ib wagon). Depending on the barrel and mount, the range of these 9.2in guns was as much as 19,200m. Other improvements were added later, including outriggers and cable anchorage systems to improve the stability of the weapon.

Independent of the army, the British Admiralty instructed the firm of Vickers Ltd to build two railway guns with 12in barrels from the naval reserve stocks earmarked for the battleship HMS *Cornwallis*. Two weapons were built and presented to the army in September 1915. These guns, designated the 12in Gun Mark IX on Mounting Railway Truck Mark I, differed greatly in size and design from Elswick's 9.2in railway guns. Weighing an astounding 171 tons, the mount and railway carriage were built as one unit. The carriage was an open box-girder frame with massive multi-wheel bogies. Despite its bulk and high-powered gun, the 12in Mark IX, unlike similar French railway guns under development at the time, could fire directly from a railway track with no special preparation of the rails and, with a range of 29,900m, it was by far the longest-range railway gun fielded in 1915. Notably, it was also the only British railway gun not built by Elswick. Both guns were operating in France by the end of the year.

Germany did not build any railway artillery in 1914 or 1915; however, an initial step was taken when eight naval 38cm cannons – christened 'Lange Max' – were mounted to iron and concrete firing platforms and emplaced in several positions behind the front. Operated by the navy, the guns shelled Dunkirk, Verdun and other French cities at distances up to 38,000m, prompting the French to build artillery pieces with very long range as a counter. The Germans soon fielded other types of foundation guns, creating a category of artillery called *schwerstes Flachfeuer* ('super-heavy flat trajectory fire') guns, some of which were subsequently converted to railway artillery. On the Eastern Front, the German Army found the Russian Army's six Schneider-Canet 152mm rail-mounted guns abandoned in the artillery park of a captured fortress. Rheinmetall refitted the pieces with 7.62cm anti-aircraft guns, and in 1916 the German Army employed the pieces on the Western Front along with several other models of rail-mounted anti-aircraft guns.

Railway Guns Fielded 1914–15

Nation	Designation	Range (m)	Number Built
France	19cm Mle 1870/93	18,300	26
	200mm Pérou	11,940	2
	24cm Mle 1870/87 and 1870/93	18,800	8
	274mm Mle 1893/96 (berceau)	22,200	4
	305mm Mle 1893/96 (châssis)	19,600	8
Britain	9.2in Gun Mark I	13,300	16
	9.2in Gun Marks III, IV, IVa, VI, VIa, VIb and VIc	19,200	16
	12in Gun Mark IX on Mark I Mount	29,900	2

1916: Greater Range and Firepower

In 1916, the range and firepower of French and British railway artillery grew significantly. At Verdun and the Somme, the need for long-range fire increased as both Allied and German defences grew deeper and counter-battery fire increased in importance. The Allies fielded a new generation of railway guns with larger and longer barrels. The French remained at the forefront of railway gun construction, fielding nine new models of railway guns, while the British put seven into service. In response to the widespread use of French railway artillery on the Somme, the German Army began

converting foundation guns to rail-mounted artillery in late autumn. All told, in 1916 the number of railway guns put into service more than doubled to around 150.

France's new railway guns were the product of its March 1915 ALGP construction programme. Except for two Schneider-built 16cm Canon Mle 1893 guns, all were large-calibre pieces. The 16cm gun was a simple design built by bolting a pintle-mounted 164.7mm naval cannon onto a flat railway wagon. Both gun and wagon were partially armoured with steel plates. Although only two of the guns were made, they were valued for their mobility, all-around fire and long range, although they were the last railway guns with armoured covers built by the French Army.

Schneider's other new guns were massive weapons weighing between 150 and 165 tons. These guns were sturdy sliding-mount pieces with mount and carriage constructed as a single unit. Because the guns had no built-in traverse mechanism, a curved firing track was needed to aim the guns at their targets. Despite its crude simplicity, the design was successful and came to characterize Schneider's heavy railway guns, and curved firing tracks (called *epis* by the French) came into standard use by French railway artillery. The first of these sliding-mount guns were four 274mm Canon Mle 1893/96 and 1887 (glissement) and two 285mm Canon Mle 1893/96 pieces, which had the same mount and carriage but different barrels. Depending on the model of barrel used, the gun's range varied from 22,000 to 27,000m. The guns were fielded starting in the spring of 1916.

The performance of the 274mm gun prompted Schneider to manufacture other similar sliding-mount designs. First were eight 305mm Canon Mle 1893/96 (glissement) fielded in the winter of 1916–17, soon followed by three versions of 32cm guns which were produced in great numbers: 16 32cm Canon Mle 1870/81, 30 32cm Canon Mle 1870/84 and six 32cm Canon Mle 1870/93. The range of these 305mm and 32cm pieces varied from 16,400 to 21,600m. Together with the 274mm cannon they were successfully employed against German rear area targets during the Allied Somme offensive, and it was these guns that prompted the German Army to build its own long-range railway artillery. Schneider also built two types of platform guns mounted to railway wagons: the 240mm Mle 1903 cannon and 293mm 'Danois' Mle 1914 mortar (so named because the mortar and mount were

Most of France's railway guns were manufactured by the Schneider Company. This 32cm Mle 1870/81, fielded in late 1916, typified the sliding-mount design of Schneider's large-calibre railway artillery pieces. (G. Heuer)

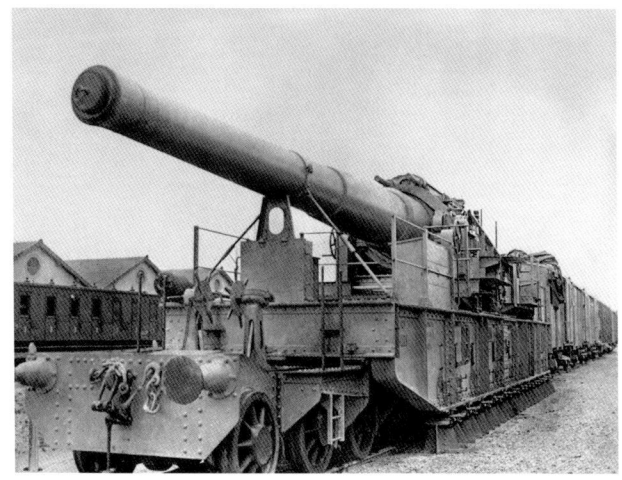

Batignolles' 305mm Mle 1893/96 used a sectional ground platform to anchor its railway carriage in place. For azimuth adjustment the barrel could be moved 5 degrees each side of centre. (G. Heuer)

15

The 340mm Mle 1912 built by Saint-Chamond in 1916 was longest-range French artillery piece of the war. Operated by both French and US railway artillery units, it was highly regarded by its crews. (NARA)

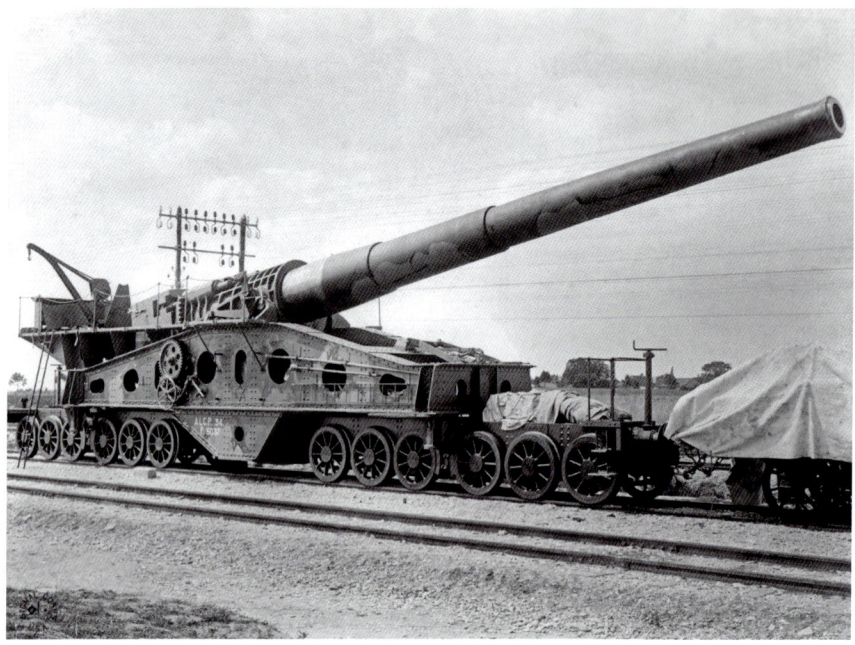

originally manufactured as coastal defence guns for Denmark). Both were hybrid designs consisting of barrel, mount and firing base plate that could fire from a standard-gauge railway wagon, but could also be removed from the rail-mount and placed on the ground for firing and, if equipped with special wheels, transported by road or narrow-gauge rail. The guns were built for the regular heavy artillery units and not employed as railway artillery, and preceded German development of dual-role railway guns able to fire from rails and ground platforms.

Although Schneider was still the primary manufacturer of railway artillery, Batignolles and Saint-Chamond continued to build small numbers of railway guns. Their new designs, unlike the improvised pieces of the previous year, were innovative and well-engineered. Batignolles made eight

B

SECOND GENERATION GUNS

A second generation of Allied railway guns, led by the French Army, came into action in 1916. The guns were purpose-built designs with greater firepower and range.

1. French 340mm Canon Mle 1912

Most French railway guns of 1916 were built using long-barrel naval guns. One of these was the 340mm Mle 1912 built by Saint-Chamond. The gun was exceptionally accurate and was the longest-range French railway gun of the war. While the gun could fire from the rails, for shelling out to maximum range, it was mounted on a fixed firing platform that increased the gun's stability and could accommodate high-angle elevation of the barrel. From 1916 onwards, French railway guns were often painted in a three-colour camouflage scheme with large patches of tan and brown painted over a base colour of green.

2. British 9.2in Gun and 12in Howitzer

Unlike the French, the British Army continued to favour smaller, more mobile weapons. Improvements were made to the 9.2in railway gun by mounting longer barrel cannons on carriages that permitted greater elevation of the barrel and all-around traverse. Several models were built, of which the 9.2in Gun Mark X (left) was the most common. For greater firepower, the army fielded the 12in Howitzer Mark I (right). Although the howitzer was mounted on a turntable, its traverse was limited to 20 degrees either side of centre because the railway wagon did not have outriggers. To correct this deficiency and improve performance, the 12in howitzer was redesigned at the end of the year.

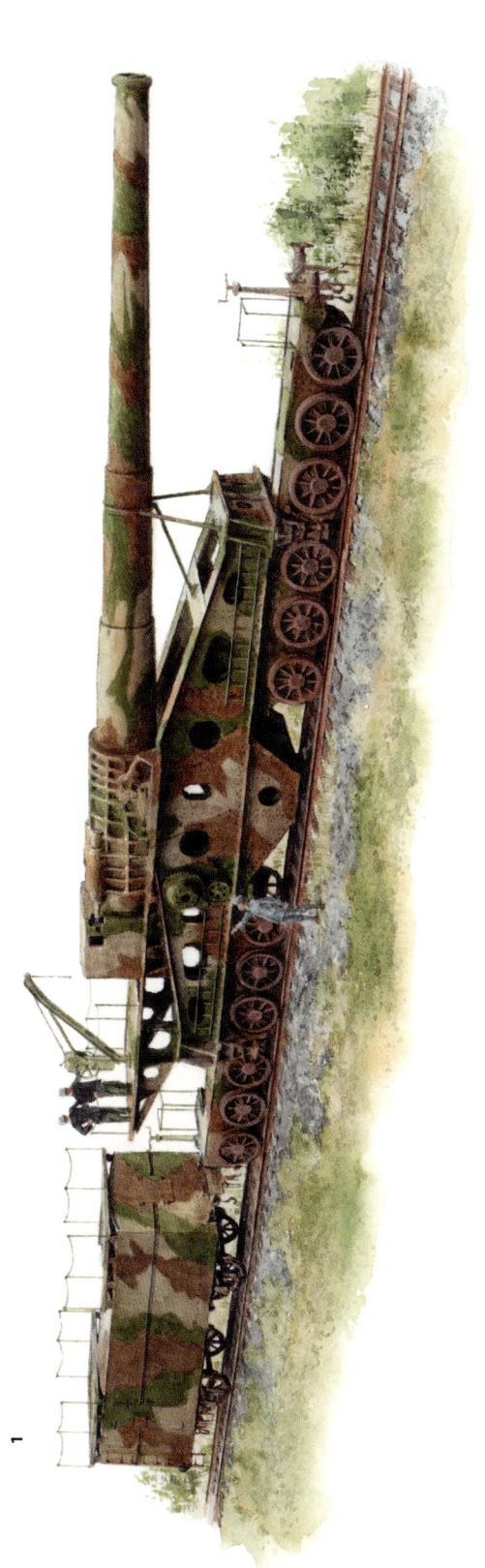
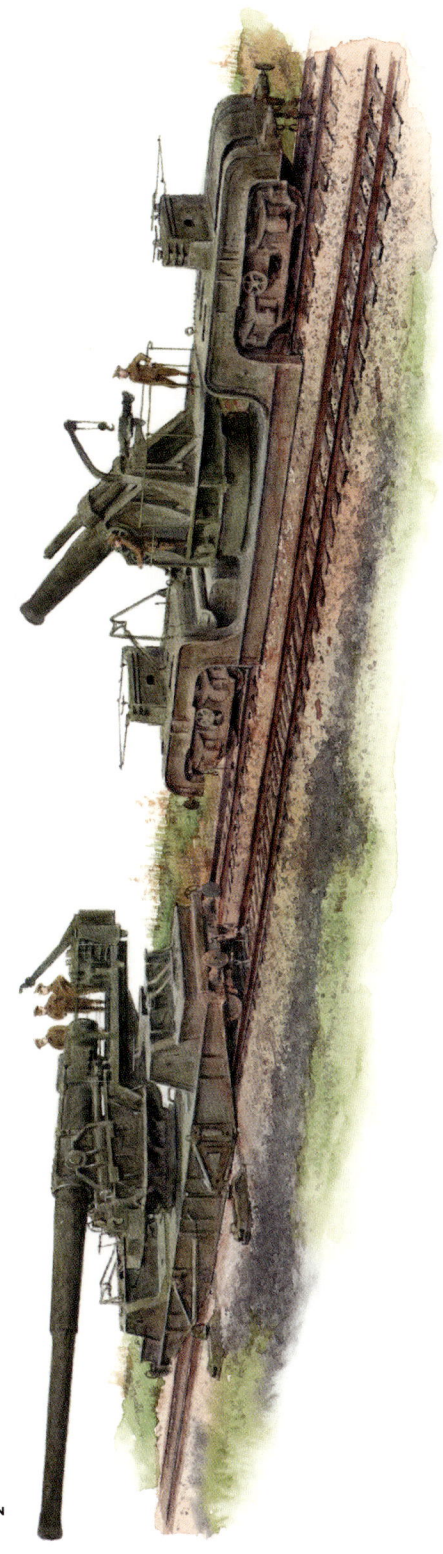

French gunners loading a 400mm Mle 1915 howitzer during a training exercise at Mailly-le-Camp in April 1916. The howitzer's carriage is mounted on a ground platform with excavated pit that allows the barrel to elevate to high angle for long-range bombardment. (G Heuer)

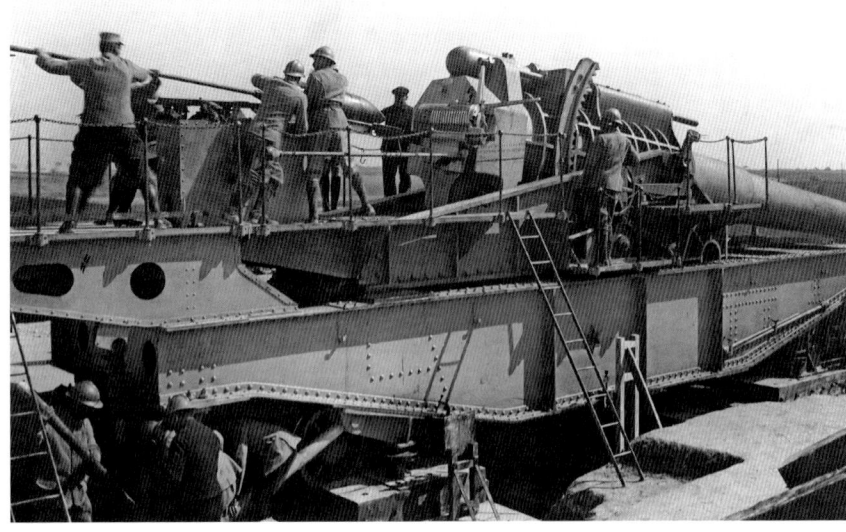

British gunners loading a powder charge into the breech of a 9.2in Gun Mark XIII near Bethune on 17 April 1918. The charge weighed about 15kg. (IWM Q 11594)

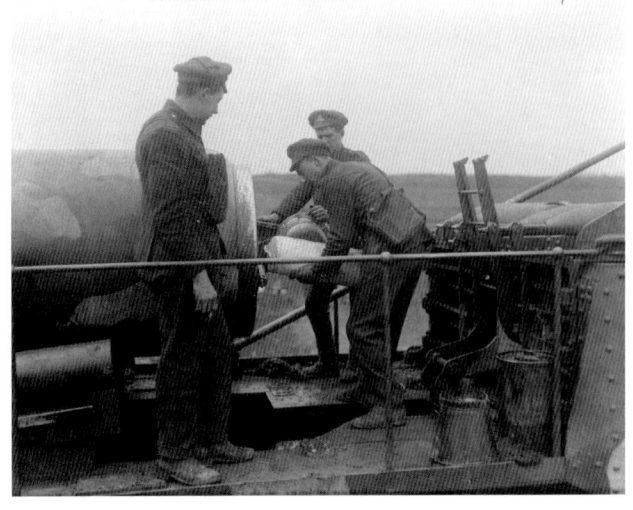

305mm Canon Mle 1893/96 (berceau) pieces with barrels recovered from a battleship that was destroyed by a magazine explosion in 1907. The gun was a straightforward, easy-to-maintain and operate piece with a very long range of 27,000m. Its novelty of design was a structural steel firing platform – called the 'Batignolles mount' – for anchoring the gun to the ground. The platform consisted of six sections laid end to end along a length of railway track. Each section had large spades on the bottom to anchor it to the track bed. The sections were bolted together and the gun's railway carriage was then placed on and locked to the mount. A specially designed railway wagon was used to transport and emplace the platform sections. The mount was successful and Batignolles used it for several of its other railway guns.

At the same time, the Saint-Chamond 340mm Canon Mle 1912 came into service. With a range of 33,200m it had the longest range of any artillery piece fielded by the French in the war. An elaborate 34-ton platform and pivot point were needed to optimize performance by allowing maximum elevation and azimuth coverage. The firing platform, constructed of wood timbers sunk into the ground to form an open pit that provided adequate clearance for barrel recoil, required two to five days to install. Despite its complex emplacement requirements, the gun was considered to be among the finest guns fielded by the French in the entire war. Four guns were employed by the end of 1916 and another two built in 1918 were loaned out to American forces. Saint-Chamond also built eight very large-calibre 400mm Obusier Mle 1915 pieces. Built purely for firepower, the howitzers had a short 16,000m range, but packed a punch.

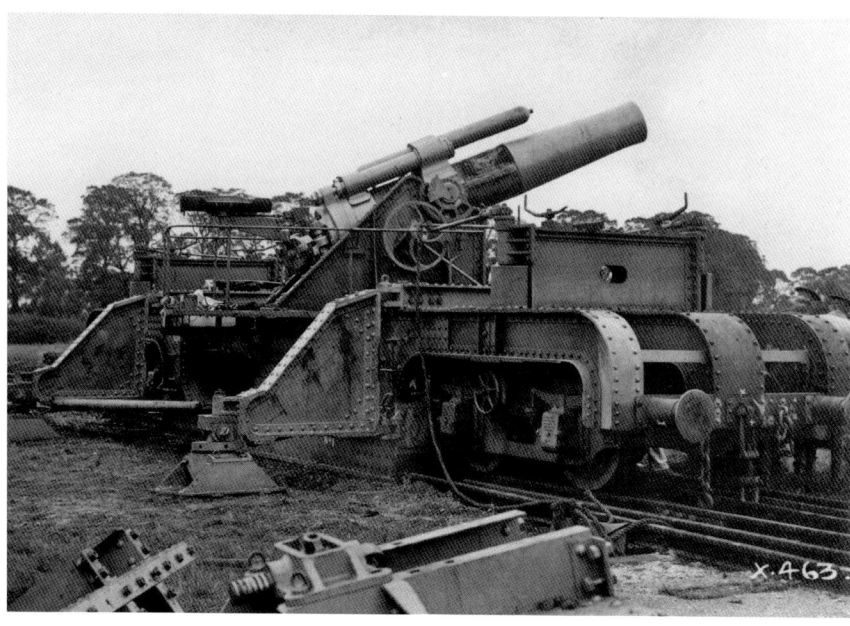

This British 12in Howitzer Mark I – identifiable by its short barrel – was retrofitted with outriggers to increase stability when firing to the side. (G. Heuer)

Fielded in the summer of 1916, the howitzers were successfully employed against German-held forts at Verdun and later, in 1917, against underground command posts and tunnel complexes in the Champagne region.

Midway through 1916, GQG planned a third ALGP construction programme. The programme ordered 25 more railway guns ranging in calibre from 240 to 520mm, most of which were sliding-mount designs. However, faced with a shortage of labour and steel for the armaments industries, GQG also instituted a stop-gap programme to mass-produce mobile heavy artillery by rail-mounting obsolete short-range coastal defence cannons. These guns, called *matériels de circonstance* (emergency equipment), were cheap and easy to manufacture and, fortuitously, had abundant ammunition stockpiles at a time when munitions manufacturing was lagging behind consumption.

Britain too began producing more railway artillery. However, in contrast to the massive 160-ton railway artillery pieces built by the French, the British Army primarily manufactured smaller, more mobile railway guns weighing around 60 tons and created a series of 9.2in guns and 12in howitzers that served as the primary weapons of the railway artillery. First, Elswick redesigned the 9.2in railway gun, giving it an improved mount with a turntable and crew platform which allowed all-around traverse and greater barrel elevation. The railway wagon was also redesigned, with the addition of a track clamp and outrigger anchorage system. Four models of 9.2in guns were used for this new design: the 9.2in Gun

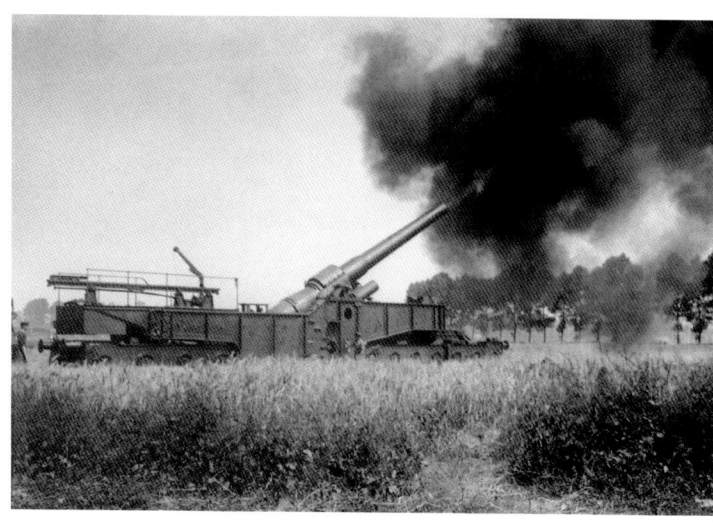

Armstrong built two 12in Mark IX railway guns for the British Army in 1916. This gun, operating near the town of Meaulte (located south of Albert) in August 1916, is firing at a target far behind German lines. (IWM Q 1370)

19

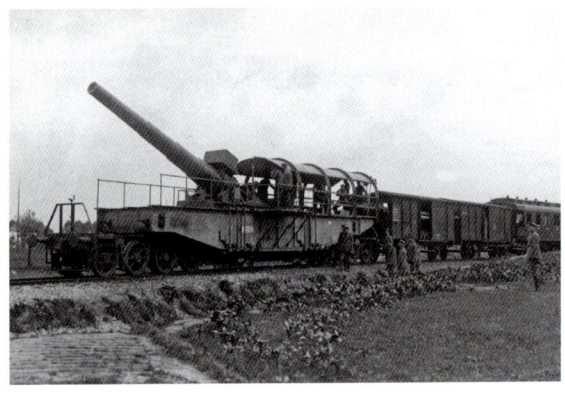
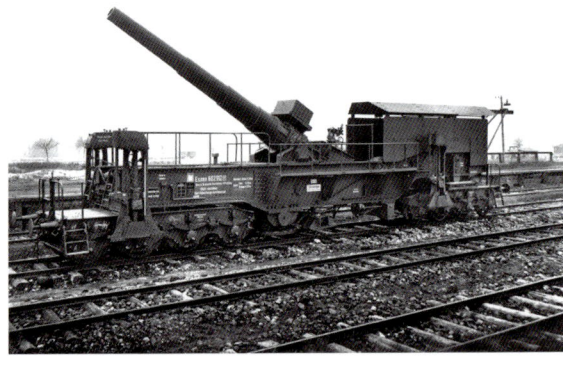

ABOVE LEFT
The German Army was a latecomer to building railway guns. Its first piece was the Krupp 24cm S.K. L/40 'Theodor Karl' E. built in response to French use of long-range railway artillery during the battle of the Somme in 1916. (NARA)

ABOVE RIGHT
In spring 1917, the German 24cm S.K. L/40 'Theodor Karl' E. was redesigned as the 24cm S.K. L/40 'Theodor Karl' E.u.B., which was the dual-role version. For mounting to a ground platform, the gun was equipped with front and rear screw-jacks and a pivot mount on the bottom of the railway carriage. (G Heuer)

Mark X, which was the primary gun mounted on this weapon; two Mark XT guns formerly intended for Australian coastal defence; and four Vickers Mark XIV 45-calibre barrels originally manufactured for a foreign order. For greater range, Elswick built the longer-barrel 9.2in Mark XIII railway gun, which could fire to 20,600m. In all, 16 new 9.2in railway guns were built.

Elswick also designed and built two models of 12in rail-mounted howitzers. The first, the short-barrelled 12in Howitzer Mark I, was a modified version of the 9.2in Gun Mark III built with heavier components to handle the recoil of the howitzer. Oddly, even though the howitzer was mounted on a turntable, the railway wagon was not equipped with outriggers, so the howitzer could not fire to the sides without risking a tip-over. This omission reduced its operational utility by limiting the barrel's traverse to 20 degrees either side of centre, so subsequent improvements included adding outriggers to the railway wagon. The first of 46 weapons entered service in March 1916, one of which was issued to the Belgian Army. Soon afterwards, Elswick built a 12in Howitzer Mark III, which was similar to the Mark I howitzer, except it had a longer barrel with 34 per cent greater range. Initial versions of the weapon also lacked outriggers, but that was soon corrected. The first 12in Mark III howitzer was ready in late 1916 and eventually replaced the Mark I howitzer.

Based on the performance of the Vickers 12in Mark IX guns in France, the British Army directed Armstrong to produce another two of the massive 12in railway guns using the same naval barrels. Elswick redesigned the carriage as

C

GERMAN RAILWAY ARTILLERY

1. 24cm S.K. L/40 'Theodor Karl' E.
Germany built its first railway artillery piece in late 1916. The gun, 'Theodor Karl', was designed to fire from its bogies using a curved firing track to aim at its target. The barrel was muzzle heavy, so a large counterweight was placed on top of the barrel, a feature that became common to most German railway guns. Four guns were fielded in spring 1917, and, although they performed well, concerns about the negative effects of gun recoil on the railway carriage prompted a redesign into dual-role gun. Most German railway guns were painted in various grey-green hues. Camouflage patterns – usually in 'dapple' style – were sometimes applied in the field.

2. 38cm S.K. L/45 'Max'
The largest-calibre railway gun built by Germany was the 38cm S.K. L/45 'Max'. The first of eight guns were fielded in time for the spring offensives of 1918. 'Max' was a dual-role gun that could fire up to 34,200m from a fixed emplacement, which provided a 360-degree field of fire and allowed the barrel to be elevated to 55 degrees. In 1918, a lighter explosive shell with a ballistic cap was developed that extended the range of the gun to an astounding 47,500m.

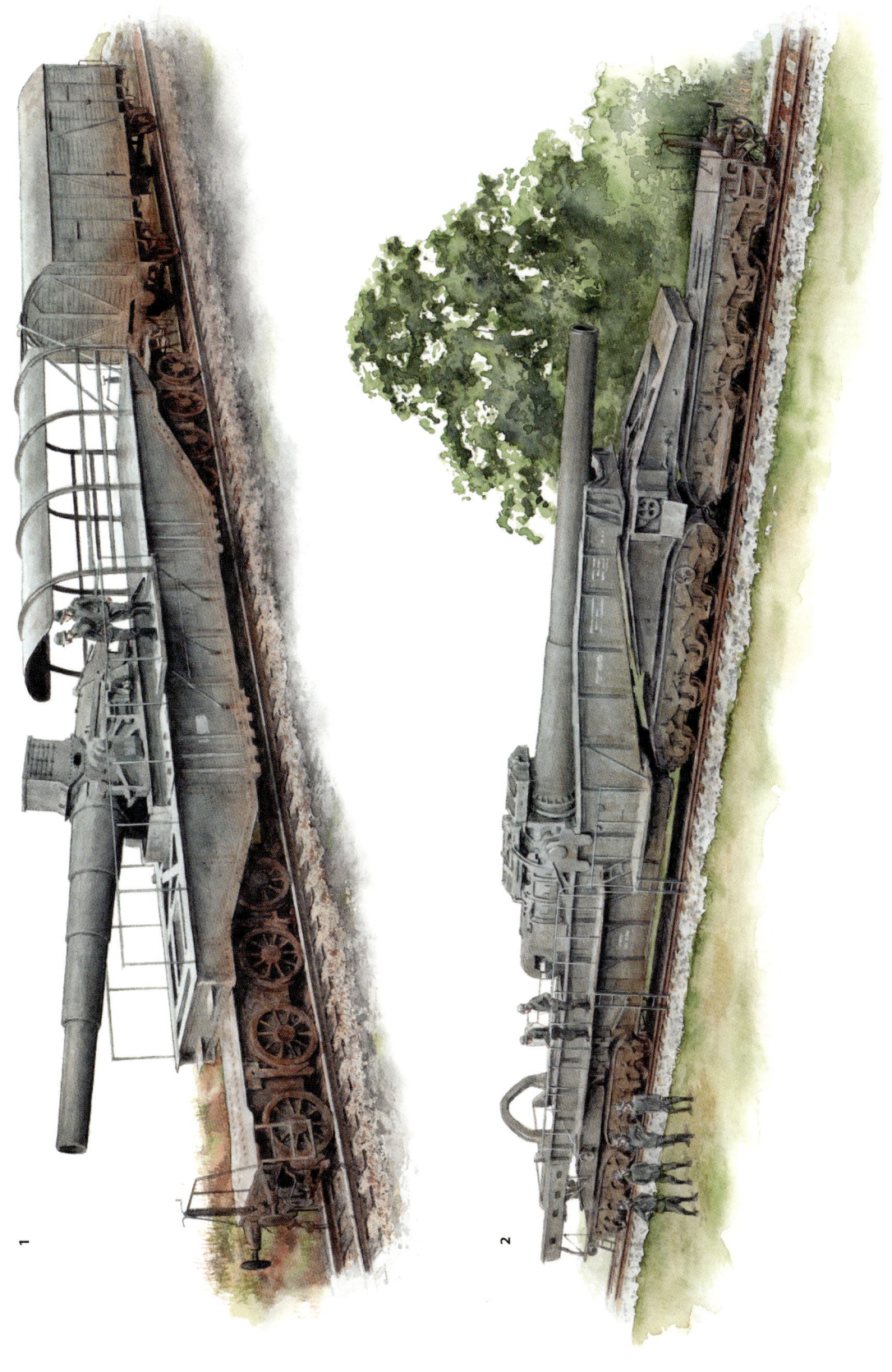

a conventional-looking railway gun with a boxed-in frame carriage. The size, weight and performance of the Armstrong and Vickers guns were analogous. Officially designated the 12in Gun Mark IX on Mounting Railway Truck Mark II, the new weapon was often called the '12in Mark IX Armstrong' to differentiate it from the Vickers model. The first of two 12in Mark IX Armstrong guns was built by May 1916, and both guns were in service in August 1916 along the Somme sector.

In the autumn of 1916, the German Navy developed Germany's first railway gun. The navy was already employing long-barrel naval guns on fixed foundations for bombarding Allied positions near Dunkirk and Verdun. However, these foundation guns were difficult to move from one location to another. To improve mobility, the Reichsmarineamt (Imperial Naval Office), the Army's Artillerie-Prüfungs-Kommission (Artillery Test Commission), and Krupp placed a 24cm S.K. L/40 naval cannon on a railway carriage in imitation of the French railway artillery. Weighing 101 tons, Krupp's gun was smaller and more mobile than equivalent French guns and could get into action within ten minutes of arrival at a firing site. Its range of 22,000m was about equal to that of most French heavy railway guns. Firing trials were conducted successfully in December 1916 at Krupp's Meppen test range, despite concerns that the railway carriage would break or deform when the gun was fired at high elevation. Named the 24cm S.K. L/40 'Theodor Karl' E., the gun was given to the army and sent to the Western Front in early 1917. The ease with which the 24cm platform gun was adapted to a rail mount led to the conversion of other 17cm, 21cm, 24cm, 28cm and 38cm naval guns to railway artillery.

Railway Guns Fielded in 1916

Nation	Designation	Range (m)	Number Built
France	16cm Mle 1893	17,400	2
	274mm Mle 1893/96 and 1887 (glissement)	27,000	4
	285mm Mle 1893/96	27,000	2
	305mm Mle 1893/96 (glissement)	27,400	8
	305mm Mle 1893/96 (berceau)	27,000	8
	32cm 1870/81	16,400	16
	32cm Mle 1870/84	21,600	30
	32cm Mle 1870/93	21,600	6
	340mm Mle 1912	33,200	6
	400mm Mle 1915	16,000	8
Britain	9.2in Guns Marks X, XT, XIV and XIII	20,600	16
	12in Howitzer Mark I	10,200	46
	12in Howitzer Mark III	13,700	46
	12in Gun Mark IX on Mark II Mount	29,900	2

1917: More Railway Guns

After the artillery battles of Verdun and the Somme, the Allies' priority of production shifted from artillery to tanks, and the development of new railway artillery pieces began to wane. Previously designed railway guns were still being built and sent to the field, but only five new models of guns were developed, two of which were the crudely manufactured *circonstance* railway pieces. Although, fielding the *circonstance* guns greatly increased the

number of railway pieces available for the front, it did nothing to boost the quality of France's railway artillery. The United States entered the war with several railway gun designs in development, but none in service. It quickly established a series of building programmes and collaborated with French artillery manufacturers to pair American industrial capacity with French experience. The German Army, wanting mobile long-range artillery, designed three new railway guns using cannons from ships decommissioned after the battle of Jutland. The use of railway artillery also expanded beyond the Western Front, with both Italy and Russia building a few heavy railway pieces. Thus, even though the development of new railway guns decreased in 1917, the total number of pieces in the field nearly doubled from that of the previous year.

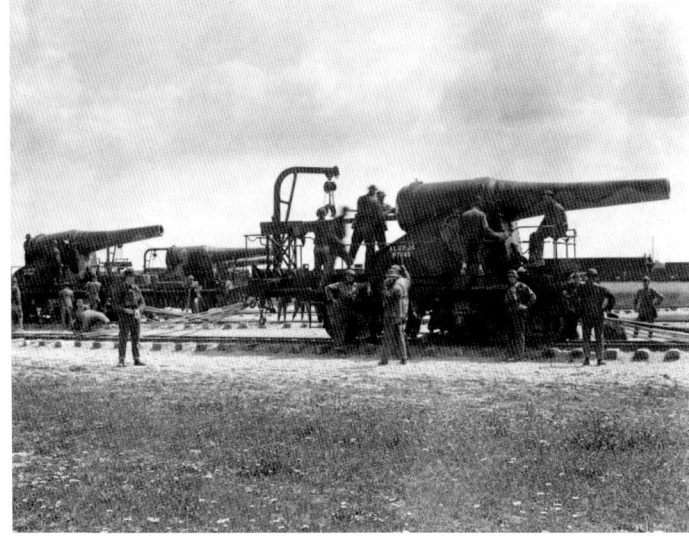

In 1917–18, the French Army mass-produced 19 and 24cm railway guns by mounting old coastal defence guns directly onto modified railway bogies. Many of these guns, such as these 24cm G Mle 1916 pieces, were used by American artillerymen for training. (NARA)

The French Army's new heavy railway guns were the eight 370mm Obusier Mle 1915 and two 340mm Canon Mle 1893 pieces. The 370mm howitzer was similar in design to the 305mm cannon built by Batignolles the previous year but, as a howitzer, it had a shorter range and much more firepower. Oddly, although the howitzer was a Batignolles design, manufacture of the guns was split between Batignolles and Schneider, which each built four pieces. In contrast, the other new gun, the Schneider-built 340mm cannon, was a very long-range artillery piece that could fire up to 26,900m and easily outrange most German artillery. From August to November, Schneider delivered 103 *circonstance* guns to the army. There were two models of guns: the 19cm Canon G Mle 1916 (the 'G' stood for *guerre* or 'war') and the 24cm Canon G Mle 1916. The 19cm pieces were made using 19cm cast-iron coastal defence cannons and obsolete top-carriage recoil mounts placed on two-axle steel railway wagons made of steel beams and girders. Having no traverse mechanism, the guns operated on a curved firing track but, for greater traverse, could be placed on a heavy timber platform for all-around fire capability. Simple to build and operate, and with a modest range of 12,800m, the guns were suitable for frontline heavy artillery.

Even simpler in design was the 24cm Canon G Mle 1916, which was little more than a coastal defence cannon and carriage bolted to a two-axle bogie turned into a railway wagon. Its range was similar to that of the 19cm cannon. Twenty-four 24cm cannons were assigned to French artillery batteries, 13 used for training, and 16 guns provided to the United States Army. Despite material and labour shortages, GQG optimistically instituted yet another ALGP construction programme that ordered 53 heavy guns in calibres 240 to 340mm and 167 cheap, mass-produced *matériels de fortune* (improvised equipment) artillery pieces, which were even cruder versions of the *circonstance* guns. However, the programme was soon scaled back, and other than the *fortune* guns, most of the planned railway guns were not built before the war ended.

The British Army's new railway gun – the 12in Howitzer Mark V – was approved for service in July 1917. Built by Elswick, it was an improvement on the 12in Howitzer Mark III, having a better barrel and recoil mechanism. Maximum range was 600m less than that of the 12in Mark III, but the capability to fire perpendicularly to the firing track was considered more important than a small loss of range. In all, 35 Mark V models were built.

In 1917, both Italy and Russia built railway guns. Italy, which had entered the war in May 1915 without any long-range heavy artillery, purchased guns from the British and French and, in the summer of 1916, temporarily received 15 French railway guns with crews. Impressed by the French artillery, the Italian Army directed the Ansaldo Company to build a railway gun using barrels manufactured for battleships the construction of which had been suspended. The gun, the Cannon 381/40 (381mm calibre bore, 40 calibre length), was an uncomplicated weapon, similar in design and operation to Schneider sliding-mount pieces. With a range of 21,000m, it was the longest-range Italian artillery piece of the war. Four guns were built and delivered in early 1917 and they saw frequent action. In Russia, the Naval Ministry – concerned about German naval activity in the Baltic Sea – ordered two railway guns built for coastal defence using 10in barrels left over from obsolete warships. These guns were simply designed with barrel and mount placed on a large, flat railway wagon. The first railway gun was completed in July 1917 at the Petrograd Metallurgical Plant but never saw action, and construction of the second gun halted when the civil war broke out in November.

When the United States entered the war, the army was already developing several types of railway guns, including large-calibre 14in and 16in pieces, for use as coastal defence weapons. Although the manufacture of several guns was well underway, only four 4.7in Gun Model 1913s were near completion. Now at war, the army quickly assembled the guns and sent them to Panama for coastal defence. Meanwhile, the Army Ordnance Department identified all the coastal defence and naval guns – including those manufactured for foreign governments – that could be used for heavy artillery and established several construction programmes to turn the guns into railway artillery. However, because the armaments industry was not fully mobilized, the

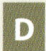

OTHER NATIONS' RAILWAY GUNS
1. Italian Cannon 381/40
Italy built only one model of railway gun during the war; the Cannon 381/40. It was a simple design manufactured by the Ansaldo Company that incorporated many features common to French railway guns. Described as being difficult to operate because of its crude recoil, elevation and traverse mechanisms, the gun's range of 21,000m compared well to large-calibre artillery used by the Austro-Hungarian and German armies on the Italian Front. An unusual feature was the armour plate roof over the crew platform as protection from strafing by aircraft. Four of the guns were built and fielded in 1917 and employed in support of operations in the Isonzo and Trentino sectors.

2. American 14in Gun, Naval Railway Mount, Mark I
The 14in Gun Mark I was built by the US Navy in response to reports that German long-range artillery was shelling the Channel ports used by the Allies. Eleven of the weapons were built by Baldwin Automotive Works, five of which were shipped to France in July 1918 and put into action in September. The distinguishing feature of the gun was its enclosed armour-plate cab meant to protect the gun and crew from German artillery fire – a feature previously used only by French designers in the first years of the war. The US Navy painted its railway guns a solid olive green colour.

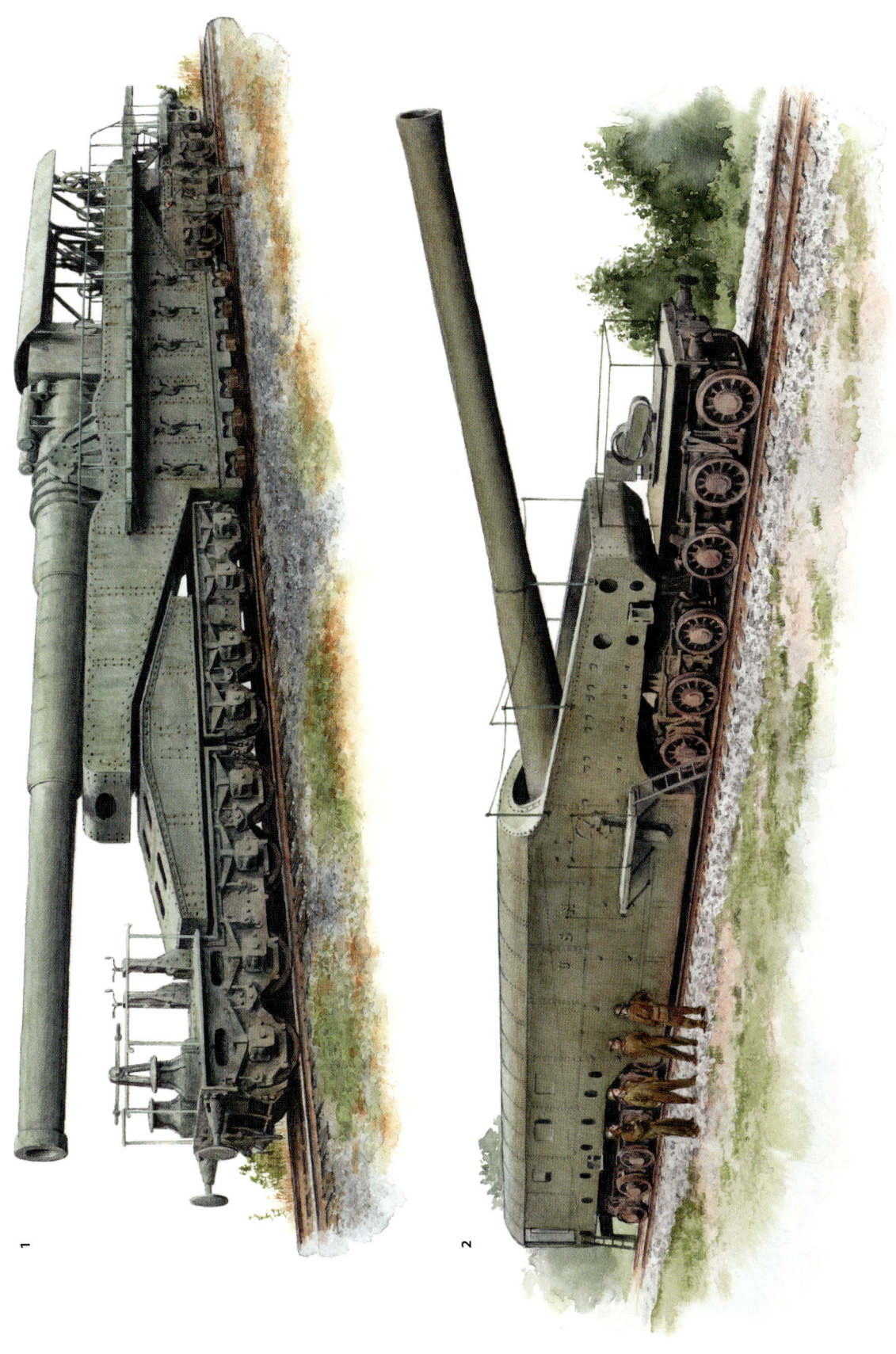

1

2

The British Army valued mobility and all-around traverse for its railway guns. This 9.2in Gun Mark XIII, operating without its outriggers, is emplaced in the sector of the New Zealand Division in May 1918. (IWM Q 10530)

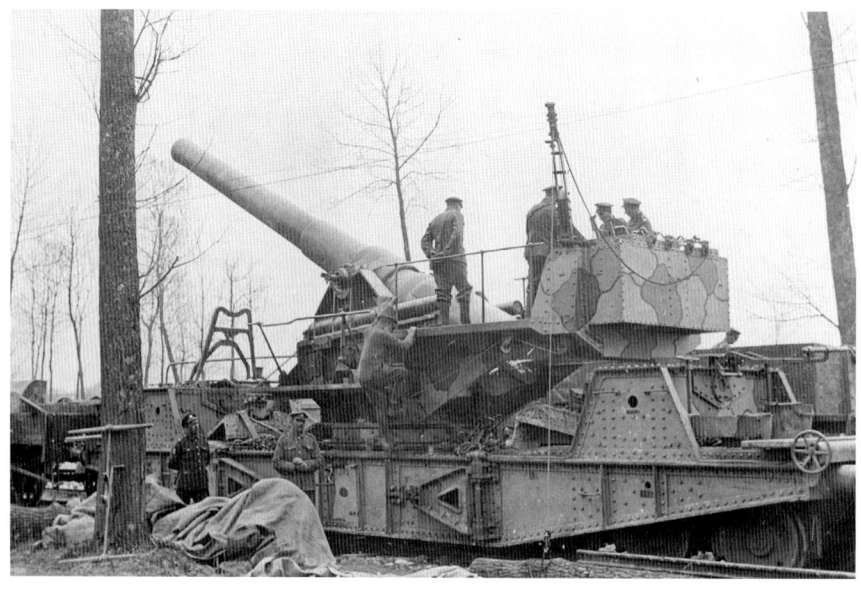

The French 240mm Mle 1893/96 'Colonies' was a rebuild of Saint-Chamond's 305mm Mle 1893/96 (châssis) using smaller-calibre cannons. Despite having a turntable mount and outriggers and braces to anchor the carriage, the gun did not have all-around traverse. (G. Heuer)

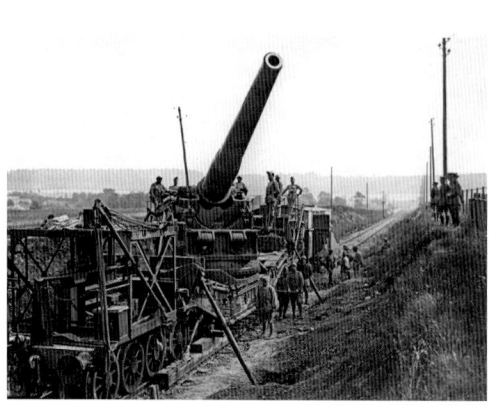

manufacture of guns was slow. One programme developed several types of light (about 75 tons) railway guns with all-around traverse as mobile heavy artillery. However, only 12 experimental 7in guns, 18 8in M1918 Guns, and several partially completed 12in M1918 Mortars were produced by the end of the war. Of these, three 8in M1918 Guns made it to France, but not in time to see action. Another programme placed 12in barrels made for a Chilean battleship onto a sliding-type mount. Designated the 12in 50-Calibre Gun, three weapons, with equipment and rolling stock, were completed and waiting for shipment to France when the armistice was declared. The army also initiated a programme to manufacture 60 14in barrels for railway guns, but the war ended before the facility to build the barrels was completed. Even larger was the massive 16in Howitzer M1918, which was similar in design and firepower to the Saint-Chamond 400mm Mle 1915, except it could be fired from the bogies without any track preparation and had a much longer range. Only one prototype howitzer was built before the project was cancelled in 1919. To accelerate the construction of railway artillery, the Ordnance Department collaborated with France to mount American 10in and 12in barrels on Batignolles and Schneider carriages. However, manufacturing difficulties critically delayed production and, although several guns were built, only one Schneider-type gun – a 10in Gun M1919 – made it to France, and then only after the war ended. To provide railway artillery for American forces in time for their combat debut in 1918, American Expeditionary Forces leased railway guns from the French Army until such time as US-manufactured guns became available.

The German Army brought its four 24cm 'Theodor Karl' E. guns into action in the spring of 1917 against French forces in the Aisne and Champagne and British forces in Flanders. The guns were valued as mobile artillery, but their limited traverse and elevation were deemed unsatisfactory. Krupp then redesigned the

'Theodor Karl' gun as a dual-role E.u.B. gun that could fire directly from the railway tracks as before, but now could also demount from its bogies and be placed on a ground platform for all-around traverse and greater range. The redesign completely changed the carriage and added screw jacks for lifting the carriage off its bogies, a pivot mechanism for attaching the gun to its platform, and traverse rollers to rotate and support the rear half of the carriage. Several days were needed to install the ground platform, but once completed, the 'Theodor Karl' E.u.B. could be emplaced on the platform in about 15 minutes. The first platforms were made of concrete, but later, removable steel platforms that could be reused and emplaced elsewhere came into use. On the Belgian coast, a Vögele turntable, named after the company that built it, was fielded. The mount resembled turntables used in rail yards to turn locomotives around, and depending on the size of the railway gun affixed, up to 360-degree rotation was possible. The new 'Theodor Karl' E.u.B. guns first entered service in summer 1917, operating on both the Western and Eastern fronts. By early 1918, 22 'Theodor Karl' E.u.B. guns were in service and, with a range of 26,600m when firing from a ground platform, they became the workhorses of German long-range artillery. A larger, sturdier carriage design, similar in function to that of the 'Theodor Karl', was used to build 20 28cm S.K. L/40 'Bruno' E.u.B. pieces for naval artillery batteries in Flanders.

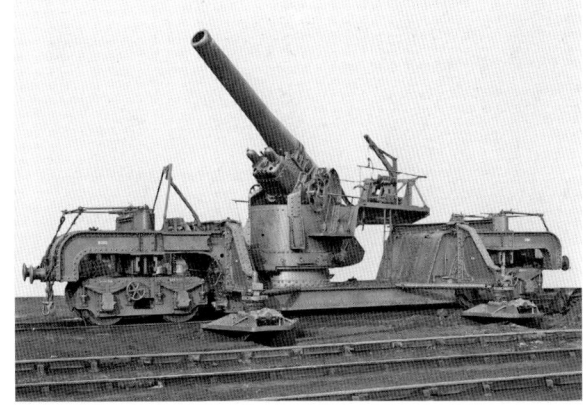

A long-barrelled British 12in Howitzer Mark V emplaced and ready for action. Fielded in May 1917, the howitzer remained in service through World War II until 1945. (G. Heuer)

As a field expediency, the German Army built the 17cm S.K. L/40 'Samuel' in *Räderlafette auf Eisenbahnwagen* (wheeled carriage on railway wagon). In late 1916 and early 1917, a number of 17cm S.K. L/40 barrels were taken from pre-Dreadnaught battleships and mounted to fixed foundations and wheeled field carriages. The first of the wheeled guns were operational in March 1917. However, weighing nearly 12 tons, the gun was too heavy for long-distance travel by horse team or petrol-powered tractors, and emplacement was too slow, taking up to two and a half days. To improve mobility, 16 17cm S.K. L/40 guns with their wheeled carriages were mounted on depressed-centre flat railway wagons. The gun carriage was attached to a pintle, but the trail severely limited traverse, so, for a wider field of fire, the guns could be dismounted from the railway wagon and placed on a ground platform.

Railway Guns Fielded in 1917

Nation	Designation	Range (m)	Number Built
France	19cm G Mle 1916	12,800	50
	24cm G Mle 1916	13,700	53
	340mm Mle 1893	26,900	2
	370mm Mle 1915	16,500	8
Britain	12in Howitzer Mark V	13,100	35
Italy	Cannon 381/40	21,000	4
Germany	17cm S.K. L/40 'Samuel'	16,900	16
	24cm S.K. L/40 'Theodor Karl' E.	26,600	4
	24cm S.K. L/40 'Theodor Karl' E.u.B.	26,600	22
	28cm S.K. L/40 'Bruno' E.u.B.	20,050	20

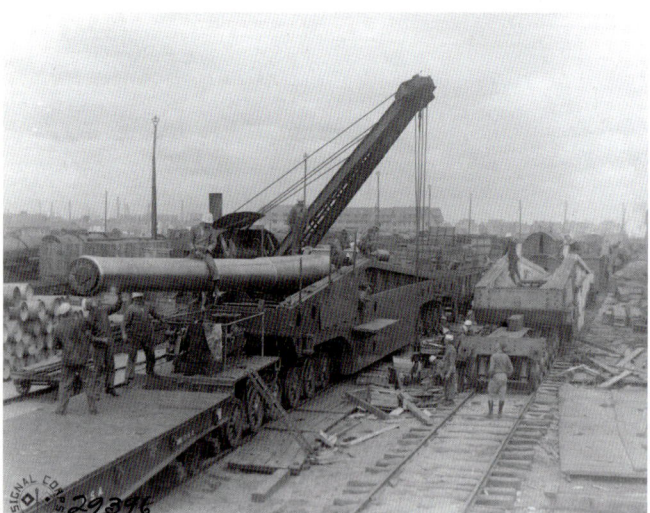

Five US 14in Mark I naval guns were shipped to France in the summer of 1918 and assembled at St Nazaire. One carriage, painted medium green, has just received its barrel. A second, unpainted carriage is in the process of being assembled. (NARA)

1918: Super-Heavy Railway Guns

In the last year of the war, as manoeuvre warfare returned to the Western Front, both France and Britain shifted more industrial resources to the production of tanks. Other than the French Army's mass-produced *fortune* guns, France and Britain only built a handful of super-heavy railway guns. American forces relied upon French railway artillery pending the arrival of US-manufactured artillery, of which only five railway guns operated by the US Navy saw action. To support its offensives on the Western Front, the German Army significantly expanded its railway artillery – although its number of railway guns never approached that of the Allies. Even though both sides lost railway guns to combat action, at the end of the war, more than 600 railway guns were in service on the Western Front.

The first new French gun fielded in 1918 was the Saint-Chamond 240mm Canon Mle 1893/96 M 'Colonies', so named because the barrels came from the colonies of Dakar and Saigon. The gun was not a new design, but rather a rebuild of Saint-Chamond's 305mm Mle 1893/96 (châssis), which had experienced problems in 1915 because its cannon was too powerful for its mount. All eight guns were re-engineered by Saint-Chamond using the 240mm cannons and adding a system of outriggers and braces. Yet, although the gun performed satisfactorily during the battles of 1918, the design remained flawed because, despite having a turntable mount, traverse was still limited to 10 degrees either side of centre. By the summer, the French Army also received 58 Schneider-built 19cm and 24cm Canon G Mle 1917

E — SUPER-HEAVY RAILWAY GUNS

In the last year of the war, the Allied armies built several super-heavy railway artillery pieces for employment during the planned 1919 offensive. A few of the guns got into action before the armistice was declared.

1. British 14in Gun Mark III

The British Army built four super-heavy railway guns using 14in naval barrels. One pair of 14in Mark III guns saw action in France with the 471st Siege Battery during the last four months of the war. Despite its massive size and weight, the 14in Gun Mark III was easy to move and ready for action because it did not require a firing platform or any special track preparations for firing. The guns were painted in a three-colour dazzle pattern of dark green, reddish-brown and sand separated by black lines. A second set of 14in Mark I guns was assigned to the 515th Siege Battery. The guns were shipped to France by section. One arrived in September 1918; the other arrived after the armistice. Neither saw action.

2. French 520mm Obusier Mle 1916

The 520mm Mle 1916 howitzer was the largest-calibre railway gun built by any army during the war. Two howitzers were ordered from Schneider in February 1916 in response to the 42cm German guns that had battered French forts at Maubeuge and Nancy in 1914 and at Verdun in 1916. The weapons weighed 260 tons and had a moderate range of 17,400m. Maximum rate of fire was one round every six minutes. Neither howitzer saw action; one was accidently destroyed during firing trials in the summer of 1918, when a shell prematurely detonated in the barrel and the other did not finish its firing trials before the war ended.

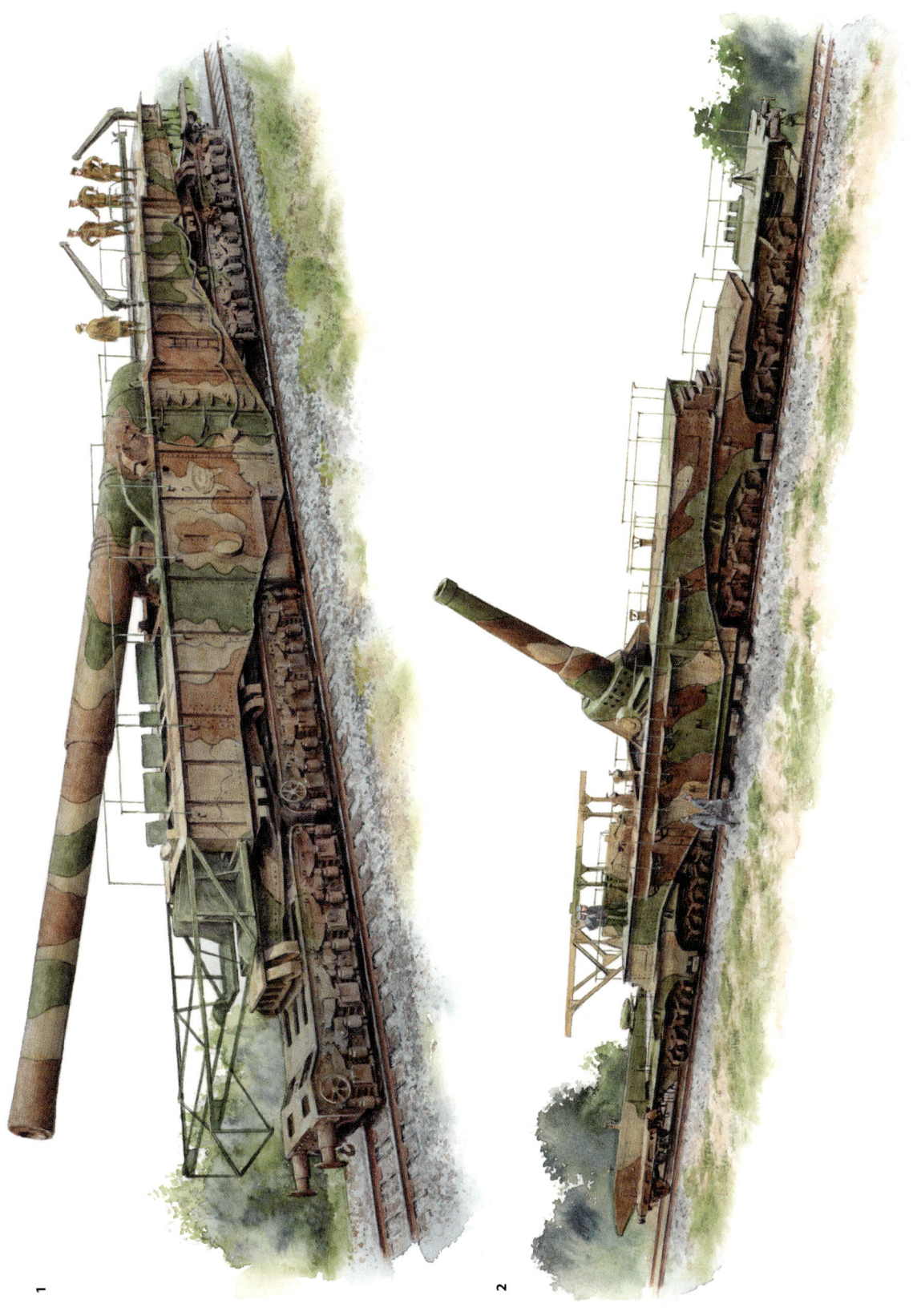

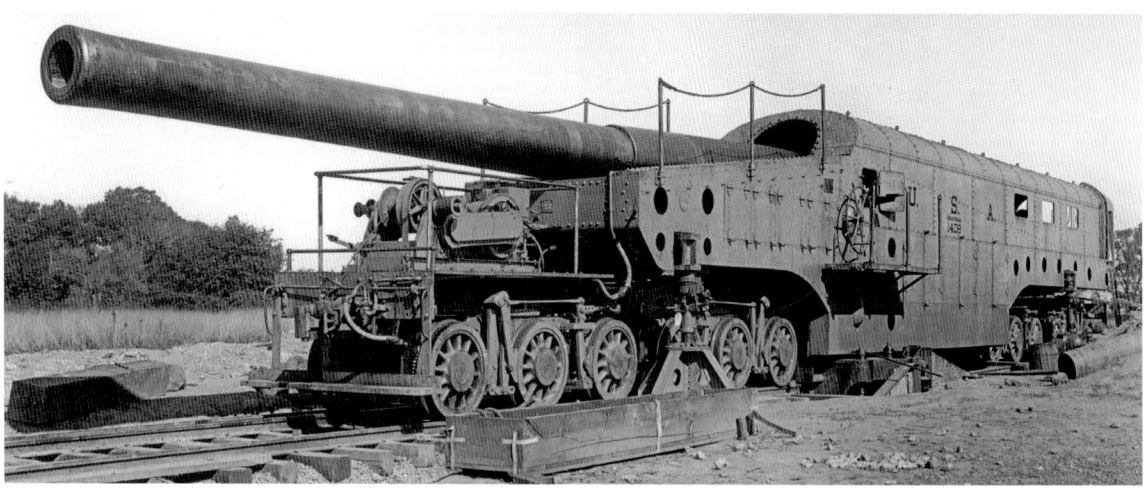

The 14in Gun Mark I, constructed by the Baldwin Locomotive Works, was the only US-built railway gun to see action in France. Five of the guns fired a total of 782 rounds in the last months of the war. (G. Heuer)

fortune pieces. The guns were similar in design, function and performance to the *circonstance* models. Many of the guns, along with other railway artillery pieces, were issued to American and Portuguese artillery units. The army was finishing two super-heavy Schneider-built 520mm Obusier Mle 1916 pieces. These howitzers were the largest artillery pieces built by any army during the war. However, neither saw action. One was destroyed during a test firing and the other was not ready before the war ended. Had the Allies attacked German permanent fortifications at Metz in 1919, then perhaps the howitzer would have proved its worth.

The British Army finished building four super-heavy 14in railway guns in 1918. These designs marked the zenith of railway gun development in the British Army. Construction began two years earlier in 1916, when Elswick proposed using naval barrels that had been built for a foreign order and not delivered. Two models of gun were built: two Mark I and two Mark III pieces. Despite weighing 248 tons, the weapons had a sophisticated recoil mechanism and carriage with long multi-axle bogies that allowed the weapon to fire from the rails without any special preparations to reinforce the firing track. Even more astounding was the guns' range of 34,700m. Both 14in Gun Mark III pieces were sent to France in May and went into action in early August. One 14in Gun Mark I was shipped to France in September 1918 but did not get into action. The second Mark I gun arrived after the armistice.

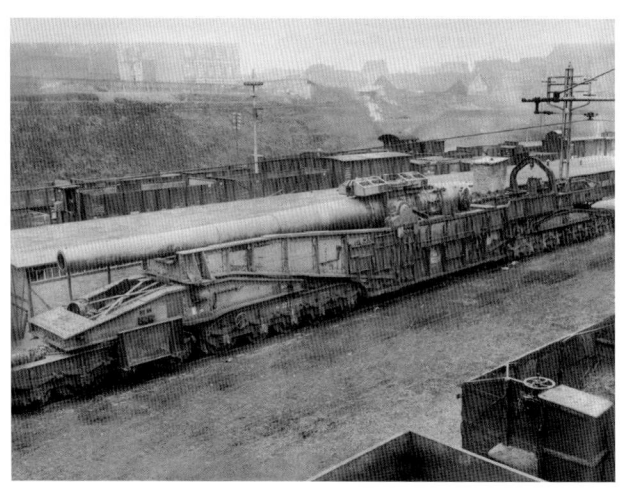

The 38cm S.K. L/45 'Max' was Germany's largest-calibre railway gun. It could fire from the rails as a rolling mount, but only when the barrel was elevated less than 18 degrees. This gun was captured by the Belgian Army. (G. Heuer)

While the US Army was still manufacturing its railway artillery, the navy successfully built and fielded its own 14in railway guns. Construction began in February 1918 at the Baldwin Locomotive Works under the supervision of the Navy Ordnance Bureau. The weapon – the 14in Gun Mark I – was a straightforward design. The most distinctive feature was a steel 'bullet-proof' cab that encased most of the carriage. The gun could fire from the tracks, but was generally operated from a

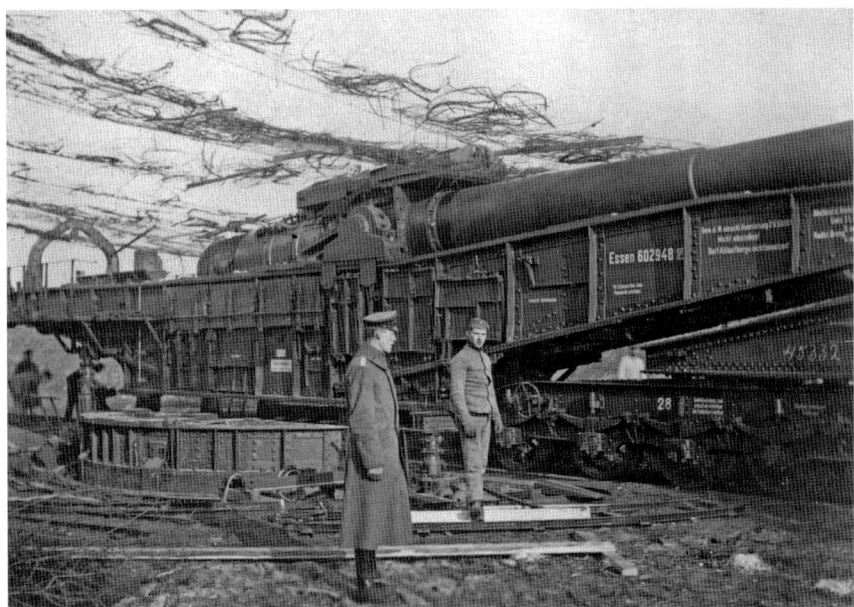

For long-range fires the German 38cm S.K. L/45 'Max' operated from a fixed ground platform. Here, the carriage is raised on its jacks with the rear bogies removed. After the front bogies are taken away, the crew will lower the carriage and bolt it to the platform. (G. Heuer)

ground platform with an emplacement pit under the carriage so the barrel could be elevated up to 45 degrees. The weapon had an exceptionally long range of 41,100m, but its massive weight (256 tons) overloaded the bogies and exceeded the axle load permissible on French railways. Five guns were shipped to France in July, assembled at St Nazaire, test fired, and then sent to the front. Operated by navy personnel, the gun's first combat action was on 26 September. Eleven Mark I guns were built by November, and an improved 14in Gun Mark II version was in development by the Navy Ordnance Bureau. The Mark II design used the same 14in/50 calibre gun as the Mark I but was not armoured, had longer bogies and a unique carriage design that could be translated from a lower travelling position upward vertically to permit maximum barrel elevation while firing from the tracks. However, the gun was not ready by war's end.

In the winter of 1917–18, Krupp built several new models of E.u.B. railway guns for the German Army's upcoming spring offensives. Most of the barrels used for the guns came from fixed platform artillery or decommissioned warships. Four 24cm K. L/30 'Theodor Otto' guns were made by mounting old 24cm cannons onto the 'Theodor Karl' carriage design adapted to accept the older model barrel, and six 28cm K. L/40 'Kurfürst' guns were built by placing old 28cm cannons onto a new carriage design. Both 'Theodor Otto' and 'Kurfürst' had 'K.' barrels, which had a slower rate of fire than the fast-loading 'S.K.' cannons of other railway guns, but the difference did not appreciably affect performance. Krupp also converted five 21cm cannons, used by the navy as fixed foundation guns since 1915, into railway pieces designated as the 21cm S.K. L/45 'Peter Adalbert'. Despite design differences, all these railway guns were functionally similar, having lifting jacks and a pivot mechanism for attaching the gun to its ground platform. The guns also had an equivalent range of about 18,500m.

Krupp also constructed eight 38cm S.K. L/45 'Max' railway guns, which were much larger in calibre and size than its other railway artillery pieces. The genesis of these guns dated back to 1915, when the army successfully

employed 38cm 'Lange Max' naval cannons on fixed foundations at Verdun, the Somme and in Flanders. At the end of 1917, when construction of several battleships was deferred in favour of U-boat production, a number of 38cm naval cannons became available for use as either ground or rail-mounted artillery. Krupp put eight of these barrels on E.u.B. mounts and delivered the first gun in January 1918. The 38cm 'Max' was the largest-calibre railway artillery gun fielded by the Germans and was employed by both the army and the navy. When fired from railway tracks it had a range of 24,000m, but from a ground platform the maximum range was 47,500m. Because of its weight – 273 tons – 'Max' needed a different ground platform than those used for the smaller 21cm, 24cm and 28cm railway guns. Instead of a pivot mechanism, the platform for 'Max' had a steel turntable. The first platforms had concrete foundations for the turntables. Later, by May, a more versatile all-steel platform that could be removed and installed at another firing site was provided for the guns.

The most famous German artillery piece of 1918, the Paris Gun – properly called the Wilhelm-Geschütz – is not considered a railway gun because it was not designed to fire from the rails, it used the railways solely for transport. But as an outgrowth of the German railway artillery programme, the Wilhelm-Geschütz represented the height of German artillery technology. Its carriage and mount design were the same as that of the 38cm 'Max' railway gun. The barrels were constructed using worn-out 38cm S.K. L/45 barrels refitted with a 21cm calibre rifled liner and extended in length to 34m. Added trusses and bracing prevented the barrel from drooping. Able to shell Paris from a distance of 128km, plans were made to extend the gun's range so it could fire on London from Calais. Depending on the source, two or three guns fired as many as 367 rounds from March to early August 1918. Yet, for all its technological innovation, the Wilhelm-Geschütz had little effect on the course of the war and was, at best, a propaganda success.

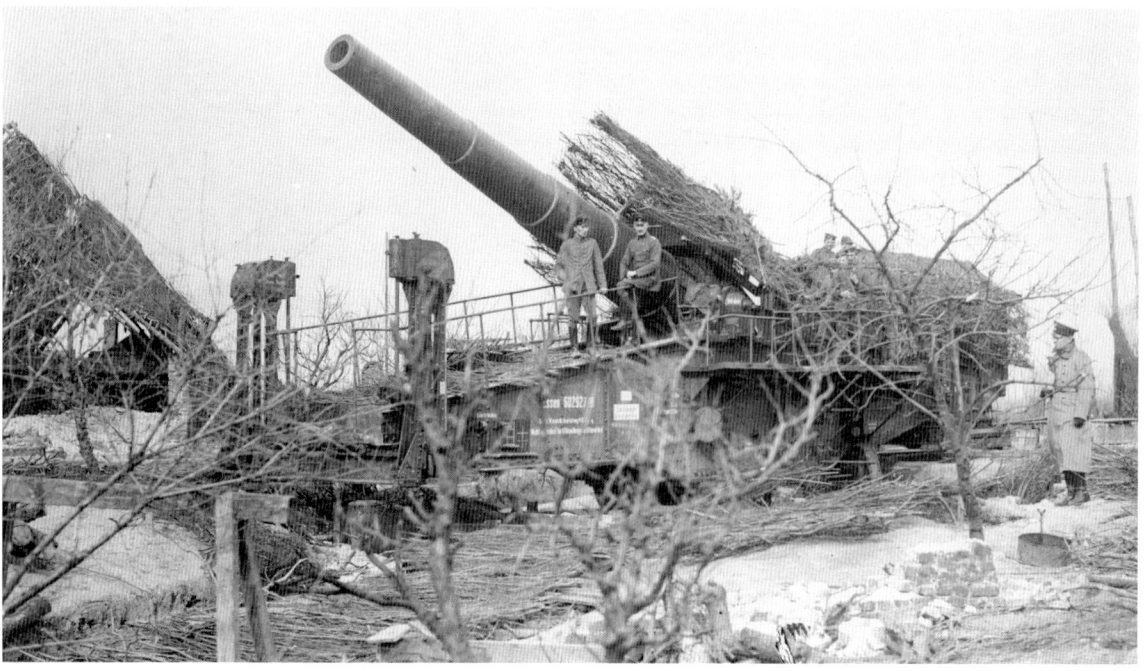

German 28cm S.K. L/40 'Bruno' railway guns were assigned to naval artillery batteries. This gun, operating in Flanders in March 1918, is mounted on a ground platform and camouflaged with brushwood to conceal it from British aerial observation. (IWM Q 56532)

At the other end of the design spectrum, in the last months of 1918, the German Army mounted 24 15cm naval cannons from pre-dreadnought battleships on railway mounts to replace out-of-action 24cm railway guns. The guns – the 15cm S.K. L/45 'Nathan' *auf Eisenbahnwagen* (railway wagon) – were crude improvised artillery pieces made by bolting naval cannons, complete with pedestal mounts and armoured shields, onto depressed-centre railway wagons. The guns had a range of 22,700m and were anchored by cables and braces for all-around fire. German railway gun development was over and 'Nathan' was the last and least sophisticated railway gun built by Germany during the war.

Had fighting continued into 1919, the Allies were poised to bring numerous new railway guns into service. Schneider was constructing more than 50 guns for the French Army. The British Army was planning to build two 18in Howitzer Mark I railway pieces, and the US Army was planning to send some 139 railway guns to France for the planned 1919 spring offensive, including 16 12in guns, 40 12in mortars, and 11 14in guns.

Railway Guns Fielded in 1918			
Nation	**Designation**	**Range (m)**	**Number Built**
France	19cm Canon G Mle 1917	12,800	30
	24cm Canon G Mle 1917	13,450	28
	240mm Canon Mle 1893/96 M 'Colonies'	22,800	8
	400mm Mle 1916	16,000	1
Britain	14in Gun Mark III	34,700	2
	14in Gun Mark I	34,700	2
United States	14in Gun Mark I	41,100	5
Germany	15cm S.K. L/45 'Nathan'	22,700	24
	21cm S.K. L/45 'Peter Adalbert'	18,700	5
	24cm K. L/30 'Theodor Otto'	18,700	4
	28cm K. L/40 'Kurfürst'	18,100	6
	38cm S.K. L/45 'Max'	47,500	8

OPERATIONAL HISTORY

Organization

The organization of railway artillery units varied by nation and evolved during the war as more and more guns were fielded. In general, the first railway guns were organized into independent artillery batteries, but by 1918 railway gun batteries were integrated with other types of heavy and long-range artillery into larger units such as groups, regiments and brigades.

The French Army designated railway guns as *artillerie lourde sur voie ferrée* or ALVF (heavy artillery on railway). The first ALVF batteries were held in reserve by the GQG and assigned to autonomous ad hoc groups for operations. In early 1917, the ALVF batteries were organized into three, and eventually five, regiments grouped into a division of the GQG heavy artillery reserve. The regiments were administrative organizations which oversaw railway gun maintenance and training. For combat, ALVF batteries were generally employed in pairs as a battalion. A typical ALVF battery had

F GERMAN DUAL-ROLE GUNS

Most German railway guns were designed to fire either on railway tracks with limited traverse and range or demounted from their bogies and placed on a fixed ground emplacement for greater traverse, often up to 360 degrees. These dual-role guns were designated as *Eisenbahn und Bettungsschiessgerüst* (railway and firing platform), or E.u.B. guns. The ground platforms consisted of turntables mounted to foundations made of either reinforced concrete or structural steel platforms. Fixed emplacements were prepared in advance so the railway guns could be quickly emplaced and put into operation. This illustration shows how the 28cm S.K. L/40 'Bruno' transitioned from rails to a platform mount. First, the gun was moved onto the emplacement so that its pivot mount (a ball race located on the bottom of the carriage that allowed the gun to rotate on the firing platform) was centred on the firing platform and two large rollers located on the rear half of the carriage were aligned to a section of curved steel rail used to roll the weapon side-to-side in azimuth (1). Two screw jacks were used to lift the front end of carriage and the bogie was detached and rolled away, leaving the front of the carriage suspended on its jacks (2). The same was then done to remove the rear bogie (3). The carriage, now suspended on its four jacks, was lowered onto the platform and the pivot mount was bolted down. The rollers were set on the circular rail to support the rear of the carriage (4).

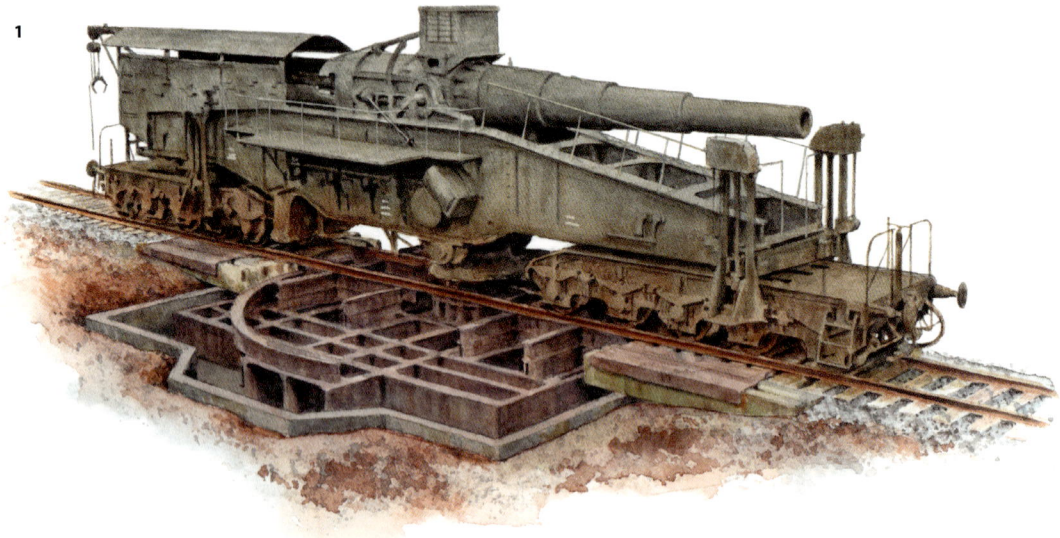

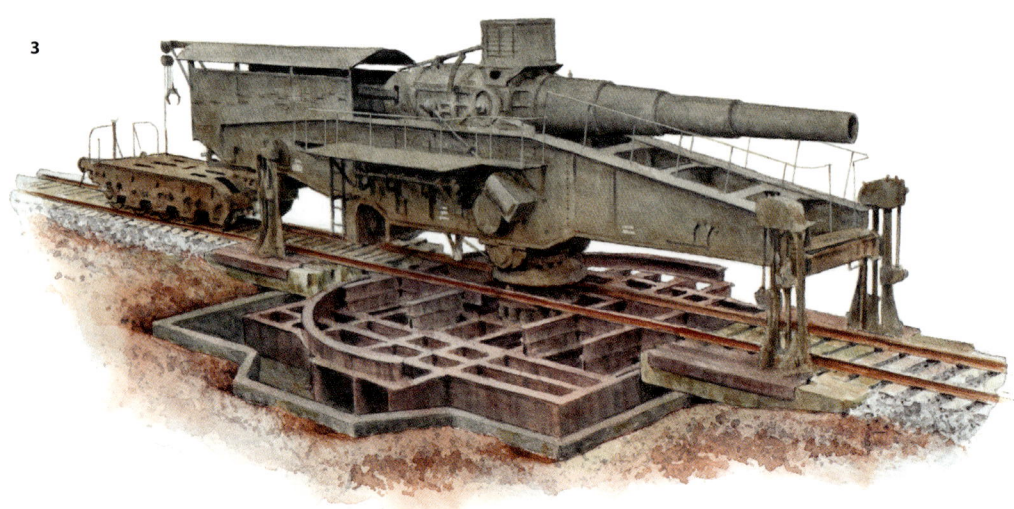

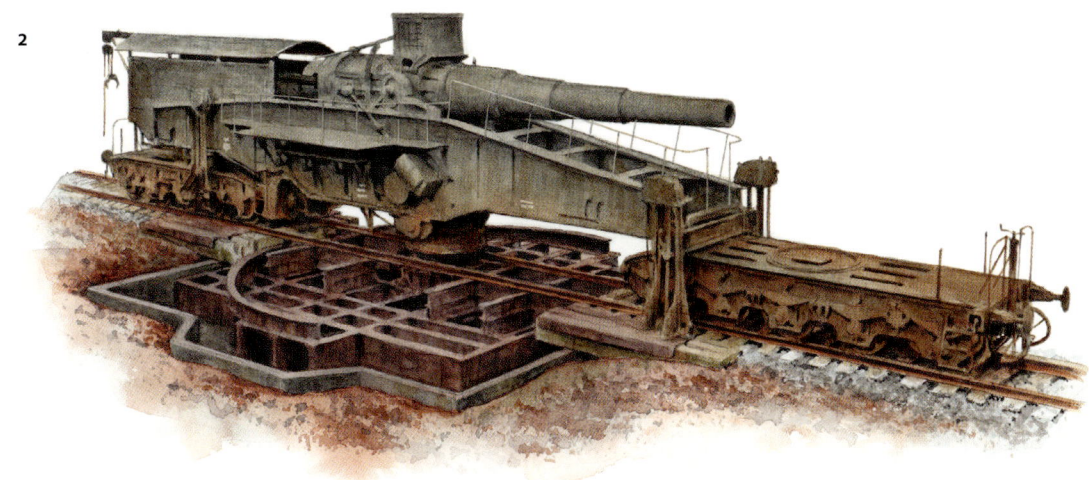

2

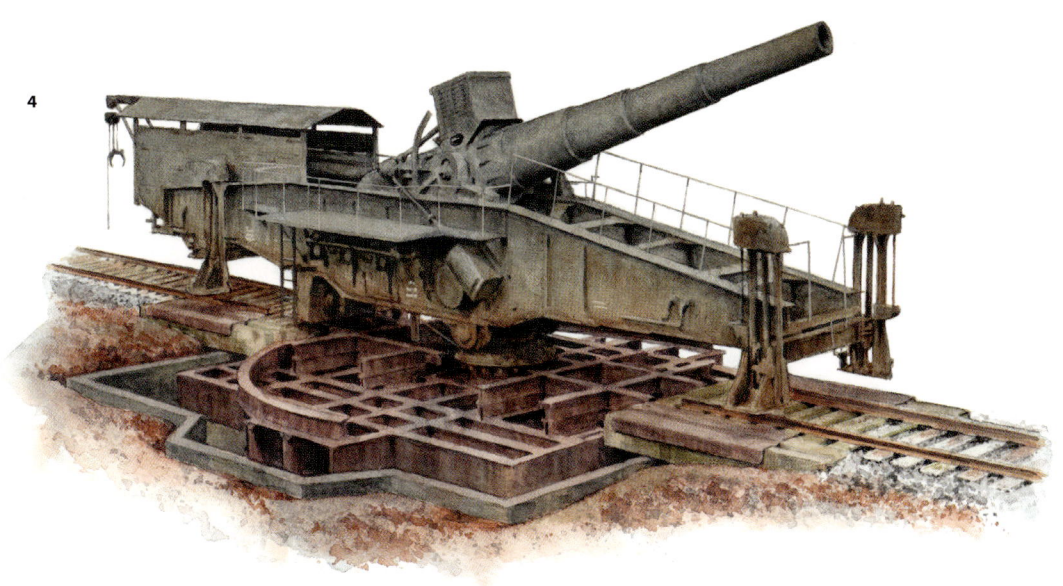

4

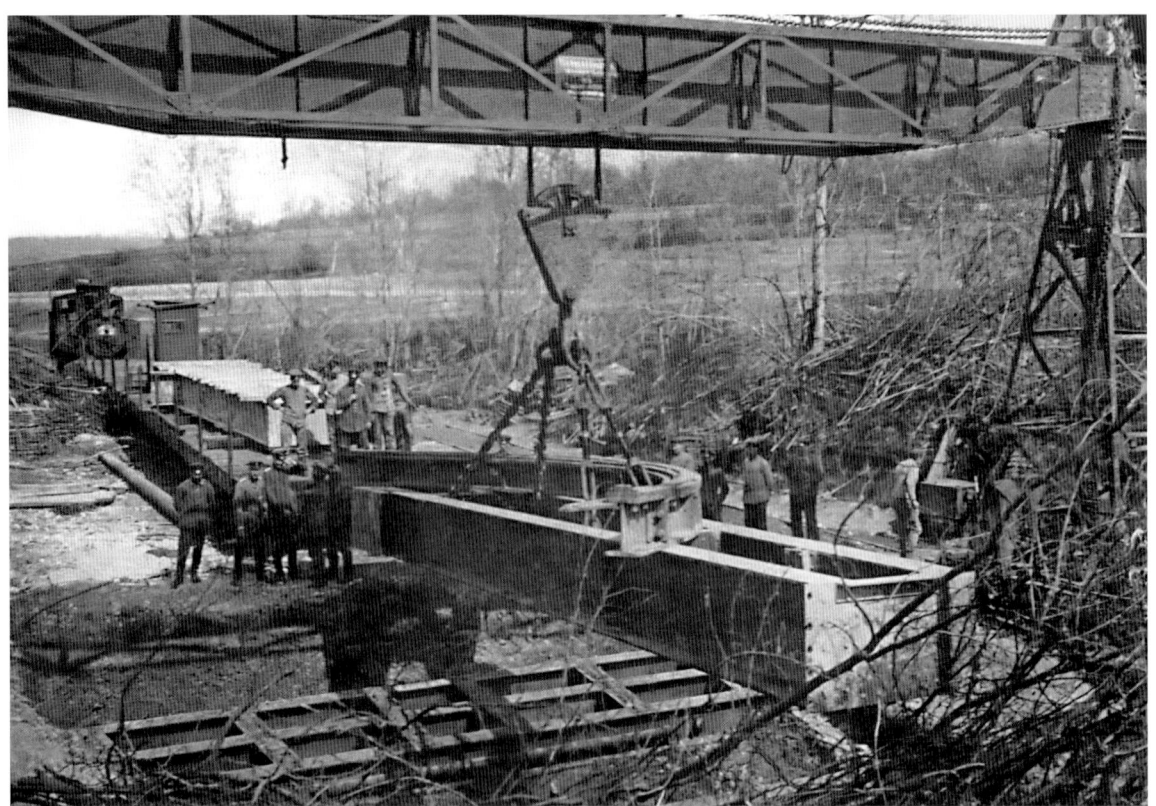

The first ground platforms used by German railway guns were made of concrete. Later platforms, such as this one for either a 24cm 'Karl Theodor' or 28cm 'Bruno' E.u.B. gun, were semi-permanent, structural steel constructions that could be moved from one location to another. (G. Heuer)

two guns, two locomotives and 20 or so railway wagons for ammunition, personnel and technical stores. Assigned strength was about 130 soldiers commanded by a captain. In 1918, some batteries were reorganized as larger batteries with four guns and 230 soldiers. The *circonstance* and *fortune* railway guns, which were treated much like regular heavy artillery, were assigned four pieces per battery.

American forces, which had 66 French railway guns, generally followed the French organization and doctrine. Railway gun batteries were assigned to the AEF Railway Artillery Reserve, which was composed of the 30th Heavy Artillery Brigade with four regiments, each with three battalions of two firing batteries. A second brigade was in the process of being formed and equipped at the time of the armistice. Railway artillery units were primarily manned by soldiers from the Coast Artillery and Ordnance Corps, except for the five 14in naval railway batteries which were organized into a naval battalion manned by naval personnel. The naval railway gun batteries had one locomotive and 12 railway wagons for ammunition, equipment and personnel. Battery strength was five officers and 66 naval personnel. There was also a battalion staff train with one locomotive and seven railway wagons.

The British Army assigned railway artillery to the Royal Garrison Artillery (RGA), which also manned the army's heavy and coastal artillery units. The railway guns, along with other types of heavy artillery, were organized into siege batteries. Batteries equipped with rail-mounted 9.2in guns and 12in howitzers were assigned to corps heavy artillery groups (renamed 'heavy artillery brigades' in 1917). Batteries with the large 12in and 14in railway guns were assigned as army-level units. One siege battery was

Despite its size and ungainly appearance, the German 17cm 'Samuel' could fire directly from its railway wagon. This piece and its ammunition wagon are painted with an unusual disruptive camouflage pattern. (G Heuer)

equipped with captured German guns in October 1918. A siege battery typically had two railway guns and, depending on the type of gun, between 70 and 140 soldiers commanded by a major. At the end of the war there were 32 batteries of railway guns in France – eight equipped with 9.2in guns, 20 with 12in howitzers, two with 12in guns, and two with 14in guns. Other than the 12in and 14in railway gun batteries, which had special ammunition wagons and an assigned locomotive, the batteries used standard rolling stock and locomotives.

Both the German Army and Navy raised and operated railway batteries. The navy had eight batteries, each with two 28cm 'Bruno' guns, and seven batteries, each with one 38cm 'Max' gun, assigned to two navy artillery regiments. Near war's end, the number of batteries was reduced and reorganized with four guns each. The 'Bruno' batteries primarily operated with the Marine Corps Flanders along the Belgian coast in a mobile coastal defence role. The 'Max' batteries were grouped with 38cm foundation gun batteries into *Marine Sonderkommandos* (Navy Special Commands) that operated in the Flanders, Pas de Calais and Champagne regions. The army organized its railway guns into independent artillery batteries assigned to a foot artillery regiment for administration, but employed by the *Oberste Heeresleitung* (Supreme Army Command). Batteries equipped with 15cm and 17cm guns usually had two pieces per battery, while batteries with 21cm, 24cm, 28cm and 38cm guns had one gun, though some batteries were equipped with two guns in the last months of the war. At its peak in 1918, the German Army had 43 railway artillery batteries, including one equipped with two captured British 12in howitzers. Assigned strength for one-gun batteries was around 130 soldiers or sailors commanded by a captain. Two-gun batteries had a strength of around 170 personnel. Railway gun battery trains had a locomotive, one or more guns, and ten to 14 railway wagons for ammunition, parts and equipment and personnel.

Crude but effective French 'fortune' railway guns such as this 19cm G Mle 1917 were used to equip American and Portuguese heavy artillery units. This weapon is emplaced on a timber platform to increase its field of fire. (NARA)

The 28cm K. L/40 'Kurfürst' gun was one of several models of railway guns built by the German Army to support the 1918 spring offensives. This gun, painted in a dapple camouflage pattern, is missing its screw-jacks for lifting the carriage off its bogies. (G. Heuer)

The last railway guns fielded during the war by the British Army were two massive 14in Mark III pieces built by Elswick. This gun, nicknamed 'Boche Buster', is in firing position near Arras. (G. Heuer)

Operation of the Railway Guns

Firing positions for railway artillery were selected and prepared before the guns arrived. The artillery staff of the supported army or corps selected the location and coordinated preparation of the firing positions, sometimes in collaboration with the railway artillery unit commander. The artillery staff also determined the location of firing tracks and platforms, observation posts, access tracks, support tracks, and facilities for ammunition, personnel and logistics needed for operating the guns. The ideal position had firm, level ground for firing tracks or ground platforms. A firing track could be any length, but was generally 150 to 200m long and curved, to give the railway gun a 10-degree field of fire. Firing tracks were reinforced with steel and wooden beams to support the gun's weight and force of recoil. Railway construction units built the approach and firing tracks, while platforms and foundations were built by the railway artillery assisted by railway construction and engineer troops. Construction of a battery position took days or even weeks, especially if ground foundations were installed. French and American railway artillery units often used multiple firing tracks in one position so the railway guns could be employed en masse. When several firing tracks were built together, they were placed at least 50m apart so the muzzle blast of one gun did not interfere with the operation of an adjacent gun. The Germans employed railway artillery as single pieces and preferred to fire the guns from ground platforms.

Railway guns moved frequently between firing positions. French and American batteries usually moved by two trains. The first, the firing train, typically had a locomotive, a workshop wagon, two ammunition wagons, and either one or two railway guns. Rolling stock was attached to the locomotive in the reverse order needed at the firing site, with the guns placed at the end of the train. The battery's second train – the administrative train – had additional ammunition wagons, a headquarters wagon, three or more berthing wagons, a kitchen wagon, and wagons for construction material and lifting equipment.

The British Army employed its railway artillery like other heavy artillery and did not assign locomotives or rolling stock to the batteries (except for the large 12in and 14in guns), but instead positioned them at intervals behind the front, where they could be called forward to support the guns as needed. German railway artillery batteries operated in a manner similar to that of the French Army, although their trains had less rolling stock.

Upon arrival at its firing position, a railway gun could be emplaced on a firing track in as little as five to ten minutes. Guns using a ground platform needed an hour or more for emplacement. Once emplaced, the gun's carriage was levelled, firing data was calculated (azimuth, range, projectile and fuse type and barrel elevation), and the gun was aimed in direction and elevation. Direction was set by aiming the barrel at a nearby known point or object and then adjusted in azimuth to point at the target. Elevation was set using a gunner's quadrant. At long distance, a minor error could result in a wide dispersion of rounds, so once basic firing data was determined, firing corrections were calculated for the difference in elevation between the gun and its target (determined by map), direction (lateral wind, rotation of the earth), and range (wind, air density, weight of projectile, muzzle velocity, barrel wear, and perhaps even curvature of the earth and displacement of the firing track during multiple firings).

Compared to regular artillery, railway guns fired fewer rounds. All firing was indirect, meaning that there was no line of sight between the gun and its target. Various observation means were used to direct the guns, and shelling a target without observation was done only when absolutely necessary. Early in the war, balloon and ground observation were used to triangulate fire on a target, but by 1916, aerial observation became the primary means for directing long-range fire. Calculating firing data for unobserved targets was accomplished using map coordinates, geometry and tabular firing tables. Calibration firings were used to conserve ammunition. A trial shot

British and American officers inspect the breech mechanism of a British 14in Railway Gun at Tincourt, France, on 26 September 1918. Two guns were built using a matched pair of naval barrels (one breech opened to the left and the other to the right). This gun's barrel has the left-hand swing. (NARA)

A German Navy 28cm S.K. L/40 'Bruno' railway gun moving to its firing position. The train consists of the railway gun; ammunition, powder and workshop railway wagons; and a locomotive. (G. Heuer)

39

French sliding-mount guns, such as this 32cm Mle 1870/84, operated on a curved firing track reinforced with steel beams. Before firing, the railway carriage was lowered onto the beams to transfer the weight of the mount from the bogies to the track. (G. Heuer)

was fired at a known target visible to observers. Based on the projectile's point of impact, the data calculated for firing on the actual target was then corrected. In two-gun batteries, one gun would fire first and then transfer firing data to the second gun. Batteries with more than one gun generally fired in salvo, in which each gun took turns firing, or volley, in which both guns fired simultaneously. Maximum range depended on the type of round fired, especially for German guns that had *Kurze Haubengranaten* (short projectiles with ballistic cap) that weighed about half of other projectiles and could be fired much farther.

G — EQUIPMENT FOR RAILWAY ARTILLERY

As railway guns grew larger and heavier they required specialized equipment for emplacement and operation. For long-range fire the French and German armies developed fixed firing platforms to anchor and stabilize their guns.

1. Batignolles Mount and Platform Railway Wagon

The French firm Batignolles developed a special railway car for use with its 305mm and 370mm railway guns. The platform wagon, as it was called, carried six sections of the firing platform and was equipped with a crane to unload and set the sections in place. Use of the platform car greatly simplified and reduced the time needed for installation of the firing platform.

2. French *Transbordeur*

Large-calibre railway guns required cranes and hoists to transfer rounds from the ammunition cars to the gun. To speed loading operations and thus increase the guns' rate of fire, the French Army built several types of *wagon transbordeur de munitions* (ammunition shuttle wagons). Used with sliding-mount guns, the shuttle wagon served as a bridge to move rounds and powder charges from the ammunition wagons to the rear of the railway gun. For transport, the shuttle wagon's extended slide could be collapsed so that it would not interfere with other railway wagons in the train.

3. German Turntable Mount for 38cm S.K. L/45 'Max'

German firing platforms permitted railway guns to rotate on the mount, providing a wide field of fire and, in some cases, all-around fire. The most sophisticated of these mounts was a structural steel turntable mount built for the 38cm S.K. L/45 'Max' and later used by the 21cm Paris Gun. Because nearly three weeks were needed for installation, the platforms were constructed well before a railway gun arrived at the position.

1

2

3

French gunners loading a 400mm Obusier Mle 1915 emplaced in a sunken position near Harbonnieres on 30 June 1916. The 400m Mle 1915 was one of the French Army's most powerful artillery pieces. (IWM Q 70524)

French gunners attach a *transbordeur* (ammunition shuttle wagon) to the rear of a 274mm Mle 1893/96. The shuttle wagon was used with sliding-mount railway guns to move projectiles and powder charges from the ammunition wagons to the gun. (G. Heuer)

Railway guns were loaded with the barrel lowered to the horizontal position. Ammunition and powder wagons were brought to the rear of the gun, then projectiles and powder charges were inspected and transferred to the gun carriage by crane or shuttle wagon. Once on the carriage, the projectiles and powder were conveyed to the loading tray of the breech via an overhead hoist or a shot trolley. The crews of small-calibre guns rammed the projectiles and powder charges into the barrel by hand, while mechanical rammers were used on large-calibre guns. German guns, which had sliding breech blocks, used brass or steel cartridges to hold the powder propellant and seal the barrel's breech. Ammunition wagons were often removed from the guns before firing, especially when operating sliding-mount and rolling-recoil guns, which might strike the wagons when the gun recoiled along the track. The rate of fire for smaller-calibre guns was about one shot per minute, while larger-calibre guns could fire once every four or five minutes. Crews often dismounted the guns when firing, particularly guns that moved when fired and very large-calibre guns with significant muzzle blast. If a gun moved under recoil, then it had to be repositioned back to its starting position. After several shots it was sometimes necessary to also readjust the ballast under the firing tracks.

Railway guns required constant maintenance when firing and were inspected daily for damage, wear and faulty functioning. If necessary, repairs were made on the spot using tools and replacement parts carried by the battery. More complicated repairs were accomplished by railway artillery repair shops or, in cases of extensive repair, such as replacement of worn-out barrels, at the works

French crewmen use an overhead gantry crane to transfer a projectile, weighing approximately 350kg, from an ammunition shuttle wagon to the breech of a Schneider 32cm sliding-mount gun. (G. Heuer)

of the manufacturer. Detailed records were kept for each piece to include the number of rounds fired, type of shell, weight of powder charge, range and elevation. Barrel life, when using maximum propellant charges, was about 6,000–7,000 rounds for the smaller calibre guns, 4,000–5,000 rounds for the larger guns, and only 500–600 rounds for the largest guns.

EMPLOYMENT AND TACTICS

Railway artillery was employed only when needed and, unlike regular heavy artillery, did not constantly occupy firing positions near the front. When not in action, railway artillery batteries were held in reserve far behind the front. An exception were the British siege batteries with 9in guns and 12in howitzers, which were employed as heavy artillery support to frontline troops and were more or less permanently in firing positions near the front. The French and American armies established cantonments for railway artillery some 50km behind the front along the main railway lines. When needed, the guns moved forward, occupied prepared firing positions, and went into action. Because railway lines within 10km of the front were generally not well maintained, only light, short-range railway guns operated that far forward, sometimes as close as 2 or 3km to the front. The heavier, and less mobile, railway guns operated from positions no closer than 10km.

Firing data for railway guns was often calculated using plotting boards. These boards were made by a German topographic section for railway artillery emplacements in the Cambrai area. (NARA)

The employment of railway artillery evolved during the war. Early on, railway guns were employed as mobile heavy artillery. By 1916, as the firepower and range of railway artillery increased, the guns took on two primary roles. One role, often given to howitzers, was to destroy strong or deeply buried fortified works – such as concrete shelters and casemates – and important targets beyond the range of regular heavy artillery, such as observation posts, supply centres and ammunition dumps. The most striking example of destructive fire by a railway gun was in April 1917, when a French 400mm Mle 1915 howitzer destroyed part of the deep Mont Cornillet tunnel complex in the Champagne region east of Reims, killing several hundred German soldiers. The other role was the interdiction of lines of communication by long-range shelling of roads, bridges, railways and rail yards located far behind enemy lines. Second, railway guns were used for counter-battery fire against enemy long-range artillery. One of the first instances of a long-range counter-battery action was the employment of two French 24cm Mle 1870/87 guns in early 1916 against a German 38cm 'Lange Max' platform gun emplaced west of Lille opposite the British Army. On occasion, long-range railway guns conducted harassment fire to lower enemy morale, sometimes by firing on towns and cities. However, concerns about barrel wear and ammunition expenditure made this an uncommon role for railway artillery. The German Army also used its railway artillery for diversionary operations, firing shots on Belfort in 1916, Nancy in 1917 and Verdun in 1918 to draw attention away from offensive preparations in other sectors of the front.

French Gunners aiming a 274mm Mle 1893/96 near Coxyde, Belgium in 1917. The Croix de Guerre with star painted on the gun indicates that the unit distinguished itself during combat. (G. Heuer)

When possible, railway artillery batteries operated from concealed locations such as ravines or woods, and approach tracks and firing positions were camouflaged using tree branches or painted canvas blinds and netting. From late 1915 onwards, the railway guns themselves were often camouflage-painted. However, camouflage and concealment were only partially effective, so deceptive measures were employed as well. False firing tracks were laid, tarps were used to simulate guns, and even fake shell holes were sometimes dug to make access tracks and firing positions appear unusable in aerial photographs. Even so, both the Allied and German armies were able to identify and locate the vast majority of railway gun emplacements using observation from advanced posts, balloons and aircraft, aerial photography, flash and sound ranging and even earth vibrations from gunfire. Railway guns emplaced within 3km or so of the front line

This damaged French 274mm Mle 1893/96 was captured by the German Army in May 1918 near Trigny, France. The gun's crew rendered the gun inoperable by destroying the breech block and exploding the ammunition in the ammunition wagon (off right side of photo), which heavily damaged the ammunition shuttle wagon and railway track. (G. Heuer)

could not remain in position for long without being detected and risked bombardment by enemy medium-range counter-battery artillery. Batteries positioned further to the rear could stay in position for several days because the enemy needed four to five days to locate the guns and bring in artillery with sufficient range to return fire. Thus, the most effective means to avoid enemy counter-battery fire was to build additional firing tracks or platforms and frequently move railway guns between firing positions.

Surprisingly, losses of railway artillery to enemy action were few. In 1918, the German Army captured several British 12in Mk II and Mark III howitzers and 14 French railway guns: six 19cm Mle 1916, one 274mm Mle 1893/96 (glissement), two 285mm Mle 1893/96, one 305mm Mle 1893/96 (glissement) and four 370mm Mle 1915 pieces. The Allies captured several pieces including several 17cm 'Samuels', one 21cm 'Peter Adalbert', one 24cm 'Theodor Karl', one 28cm 'Bruno', and one 38cm 'Max' gun, mostly in the last weeks of the war. Accurate targeting of railway guns by counter-

The German Army captured 14 French railway guns during the 1918 spring offensives. This 370mm Mle 1915 howitzer, along with its two platform railway wagons, were taken by the Germans on 30 May 1918 near Mont-Notre-Dame. (G. Heuer)

battery fire was rare. One of the few recorded incidents occurred when German artillery located and shelled a 14in Naval Gun Mk I battery position near Verdun, but, because the gun was armoured, there were no casualties among the crew. More common, yet still infrequent, was strafing by aircraft.

LEGACY OF THE RAILWAY GUNS

Railway artillery remained in service with the Allied armies after the armistice, although many guns were retired and most development programmes were curtailed. The French Army scrapped its older improvised weapons, especially the *circonstance* and *fortune* guns. What remained was put into storage under the care of a single ALVF regiment, of which some 100 guns were mobilized in 1939. In the 1920s, in imitation of the German Wilhelm-Geschütz, the French Army built several experimental railway guns that fired as far as 127,800m, but the guns were deemed impractical. The British Army put some of its 9.2in guns and 12in howitzers in storage, a few of which saw service in World War II. Two of its 14in Mark III guns were kept until the barrels were scrapped in 1926, while the carriages were retained and later rebuilt to mount 13.5in and 18in guns. The Italians put their four 381/40 railway guns into storage, where they remained until the end of World War II. The US Army scrapped many of its railway guns, but kept some 7in and 8in guns and 12in howitzers for coastal defence. In the 1920s, the army applied its wartime experiences to the design and construction of four dual-role 14in M1920 guns. The guns, along with some 8in guns, saw service in World War II as coastal defence artillery. Other than the railway guns captured or taken by the Allies, all but 24 guns kept by the German Army for coastal defence (four 'Peter Adalberts', 12 'Theodor Karls' and eight 'Brunos') were destroyed under the disarmament provisions of the Versailles Treaty, although some components were hidden from the Allied control commissions.

Railway artillery returned to service in World War II, particularly with the French and German armies, but not nearly in the numbers employed during World War I. Interestingly, Belgium fielded several World War I-era German railway guns in 1940, which were recaptured by the German Army and, along with guns taken from France after its defeat, put into service for the rest of the war.

The Soviet Union, Britain, Italy, the United States and even Japan built or employed railway guns, mostly in coastal defence roles.

Very little exists today of the World War I railway guns. One complete gun survives – a US Navy 14in Gun Mark I located at the Washington Navy Yard in Washington, DC – and a barrel from a German 28cm 'Bruno' captured by Australian troops in 1918 is preserved as part of the Australian War Memorial in Canberra, Australia. Several World War I-era Allied railway artillery pieces that were constructed too late to see service in the war remain: a US 12in Howitzer M1918 at Fort Lee, Virginia; a US 8in M1918 Gun (less railway wagon) on the campus of the University of Tampa in Florida; and a British 18in Howitzer Mark I barrel at Fort Nelson in the UK. Also, there are a few projectiles and shell casings in museum collections, and several ground platforms built by the German Army still exist in the forests north-west of Paris and near Verdun.

BIBLIOGRAPHY

François, Guy, *Les Canons de la Victoire 1914–1918: Tome 2: l'Artillerie Lourde a Grande Puissance* (Histoire and Collections: 2008)
Hogg, Ian, *Allied Artillery of World War One* (Crowood Press: 1998)
Jäger, Herbert, *German Artillery of World War One* (Crowood Press: 2001)
Marble, Sanders (ed.), *King of Battle: Artillery in World War I* (Brill: 2016)
Miller, Harry W. II, *Railway Artillery: A Report on the Characteristics, Scope of Utility, Etc., of Railway Artillery* (United States Army Ordnance Dept: 1921)
Schirmer, Hermann, *Das Gerät der schweren Artillerie vor, in und nach dem Weltkrieg* (Verlag Bernard & Graefe: 1937)

INDEX

Note: locators in bold refer to illustrations and captions. All military hardware listed is French unless otherwise stated.

aerial and ground observation 39
Allies' shift to tank production 22, 28
ALPG construction programmes 12–13, 15, 19, 23
ammunition and projectile loading 42, **42**, 43
anchorage systems 8, 10
Anglo-Egyptian War (1882) 4
armoured housing 10, **10**, **A(10)11**, 12, **12**, **D(24)**
Armstrong, Whitworth & Company 12, 13, 19, 20-22
azimuth coverage 7, **15**, 18, 39

barrels 4, 6, 8, 12, 13, 14, 15, **15**, **18**, 19, **19**, 20, **C(20)21**, 24, 26, 27, 28, **28**, **E(28)29**, 30, **30**, 31, 32, 39, **39**, 42–43, 46
battery position construction 38
breech mechanism 18, 39, 42, 43, 45
British Admiralty, the 14
British Army, the 5, 6, 7, 13, 19, 26, 30, 33, 39
 RGA (Royal Garrison Artillery) 36–37

camouflage **A(10)11**, **B(16)17**, **C(20)21**, 32, 37, 38, 44
carriage traversing 7
circonstance railway guns 8, 22–23, 30, 36, 46
coastal defence guns 4, 5, 6, 7, 9, 10, 12, **12**, 13, 16, 19, 20, 23, 23, 24, 46
codenames in German nomenclature 8–9
components 6
cradle recoil 7
Croix de Guerre, the 44
curved firing tracks 7, 10, 15, **C(20)**, 23, **F(34)**, 38, **40**

design and development 6–8, 10–11, 13, **13**, 15–18, 19, 20, **C(20)**, 22–24, **D(24)25**, 26, 26–27, 28–30
elevation mechanisms 6–7, **10**, 13, 18, **C(20)**, 30, 31, 39
emplacement 39, 44–45
equipment for emplacement and operation **G(40)41**
evolving roles of railway artillery 44
experiments in early guns 5

field of fire **C(20)**, 27, 37, 38, **G(40)**
firing data calculation 39–40, 43
firing positions 38, 39, 43, 45
fortune railway guns 8, 23, 28, 30, 36, **37**, 46
French Army, the 4, 5, 9, 15, **G(40)**
 ALVF batteries 33–36, 46
German Army, the 5–6, 14–15, 23, 28, 33, 44, **45**, 46
 Marine Sonderkommandos 37
German dual-role guns **F(34)35**
German Navy, the 22, 39
ground platforms 6, 8, **15**, 16, **18**, 20, 27, 31, **31**, 32, **32**, **F(34)**, 36, 38, 39, 46
gun types 6, 8

indirect fire techniques 4, 39
Italian Army, the 24

labour and material shortages 19, 23
long-range artillery construction 10, 31, **G(40)**
long-range counter-battery action 44–45
losses of railway artillery 28, 45, 45–46

maintenance and repair 42–43
memorial exhibits 46
mobility 6, 15, 22, **26**, 27, **E(28)29**
Mont Cornillet tunnel complex 44
Mount and Platform Railway Wagon **G(40)41**
mounts 5–9, 10, **A(10)11**, 12, 13, 14, 16, **B(16)**, 18, 19, 20, 23, 26, 28, 30, 32, 33, **F(34)35**, 40, **G(40)41**, 42, 43

nomenclature systems 8–9, 24
non-traversing guns 7

origins of railway artillery 4–6
outriggers 7, **7**, 8, **A(10)**, 13, 19, 20, 26, 28

Paris Gun (Wilhelm-Geschütz) (Germany) 32, **G(40)**, 46
planned 1919 offensive 4, **E(28)**, 30, 33
Piegne-Canet carriages 5
production 14, 22, 24–26, 28
project cancellations in 1919 26

railway artillery units organization 33–37
railway guns
 4.7in Gun Model 1913 (US) 24
 8in M1918 Gun (US) 46
 9.2in Gun Mk I (UK) **A(10)11**, 13, 14
 9.2in Gun Mk III (UK) 8, **A(10)11**, 12, 13, 14, 20
 9.2in Gun Mk X (UK) **B(16)17**, 19–20, 22
 9.2in Gun Mk XIII (UK) **18**, 20, 26
 12in 50-Calibre Gun (US) 26
 12in Howitzer Mk I (UK) 19, 20, 22
 12in Howitzer Mk II (UK) 45
 12in Howitzer Mk III (UK) 20, 22, 24, 45
 12in Howitzer Mk V (UK) 24, 27
 12in Mark IX gun (UK) 13, 14, **14**, 19, 20–22, **22**
 14in Gun Mark I (UK) 30, 33
 14in Gun Mark I (US) **D(24)25**, 28, 30, 30–31, 33, 46
 14in Gun Mark II (US) 31
 14in Gun Mark III (UK) **E(28)29**, 30, 33, 38, 39, 46
 14in M1920 gun (US) 46
 15cm S.K. L/45 'Nathan' (Germany) 33, **33**
 16cm Mle 1893 gun 15, 22
 16in M1918 Howitzer (US) 9, 26
 17cm S.K. L/40 'Samuel' (Germany) 27, **27**, 37, 45
 19cm Canon G Mle 1916 23, 27, 45
 19cm Canon G Mle 1917 28–30, 33, 37
 19cm Mle 1870/93 9, 10, **A(10)11**, 12, 14
 21cm S.K. L/45 'Peter Adalbert' (Germany) 31, 33, 45, 46
 24cm Canon G Mle 1916 23, 27
 24cm Canon G Mle 1917 28–30, 33
 24cm Canon Mle 1870/87 12, **14**, 44
 24cm K. L/30 'Theodor Otto' (Germany) 9, 31, 33
 24cm S.K. L/40 'Theodor Karl' E. (Germany) 20, **C(20)21**, 22, 26, 27, 31, 45, 46
 24cm S.K. L/40 'Theodor Karl' E.u.B. (Germany) **20**, 27, **27**, 31, 36
 28cm K. L/40 'Kurfürst' (Germany) 31, 33, 38
 28cm S.K. L/40 'Bruno' E.u.B. (Germany) 27, **27**, 32, **F(34)35**, 36, 37, 39, 45, 46
 32cm Mle 1870/81 15, **15**, 22
 32cm Mle 1870/84 5, **15**, **22**, 40

 32cm Mle 1870/93 15, **22**
 38cm cannon 'Lange Max' (Germany) 14, 32, 44
 38cm S.K. L/45 'Max' (Germany) **C(20)21**, 30, **31**, 31–32, **33**, 37, **G(40)**, 45
 95mm Mle 1888 (France) 10
 155L 'Transvaal' cannon 9, 10
 200mm 'Pérou' howitzer 7, 9–10, **A(10)11**, 14
 240mm Mle 1893/96 **26**, 28, 33
 274mm Canon Mle 1893/96 10, 10–12, **12**, **14**, 15, 22, 42, 44, 45, **45**
 285mm Canon Mle 1893/96 15, **22**, 45
 293mm 'Danois' Mle 1914 15–16
 305mm Canon Mle 1893/96 12, **14**, 15, **15**, 18, **22**, 26, **28**, **G(40)**, 45
 340mm Canon Mle 1893 23, 27
 340mm Mle 1912 16, **B(16)17**, 18, 22
 370mm Obusier Mle 1915 23, **27**, **G(40)**, 45, **45**
 400mm Mle 1916 33
 400mm Obusier Mle 1915 **18**, 18–19, 22, 26, 30, 44
 520mm Mle 1916 **E(28)29**
 Cannon 381/40 (Italy) 24, **D(24)25**, 27, 46
ranges 9, 10, 10, 12, 13, 14, **14**, 15, 18, 20, **C(20)**, 22, 23, 24, **D(24)**, 26, 27, 27, **E(28)**, 30, 31, 32, 33, 40
rate of fire 31, 42
recoil 7–8, 10, **C(20)**, 24, **D(24)**, 30, 42
rolling recoil 8, 42
Russian Naval Ministry 24

Saint-Chamond 12, 16, **16**, **B(16)**, 18, 26, 28
Schneider Company 5, 7, 7, 8, 9, 10, **A(10)**, 12, 14, 15, **15**, 16, 23, 28, **E(28)**, 33
schwerstes Flachfeuer guns 14
scrappage and storage of guns 46
Second Boer War (1899–1902) 4–5, 9
second generation guns **B(16)17**
shelling of infrastructure 44
shortcomings in design 13, **B(16)17**, 20, **C(20)**, 26, 28
sliding-mount guns 7, 8, 15, **15**, 19, 24, 26, **G(40)**, 40, 42, **42**, 43
sliding recoil 7–8
Société des Batignolles 9, 16–18, 23, **G(40)**
Spring offensives of 1918 **C(20)**, 31, 38, 45
super-heavy railway guns **E(28)29**, 28–33

top-carriage recoil 7, 10
top-carriage traverse 7
training and trials 18, 22, 23, **E(28)**, 31
Transbordeur shuttle wagon **G(40)41**, 42
transport of railway guns between firing positions 38–39
traverse mechanisms 7, 10–12, 13, 15, 23, 27, 28
turntable mount **G(40)41**

US Army, the 23, **23**, 24, 30, 33, 46
 AEF Railway Artillery Reserve 36
US Civil War, the 4
US Navy, the 28

Versailles Treaty, the 46
Vickers Ltd. 13, 14, 20, 22

weights 6, 7, 8, 10, 22, 27, **E(28)**, 30, 31, 32
World War II 46

48